The St. Albans Psalter

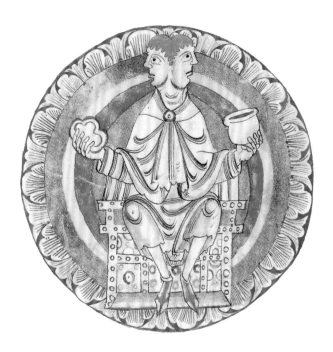

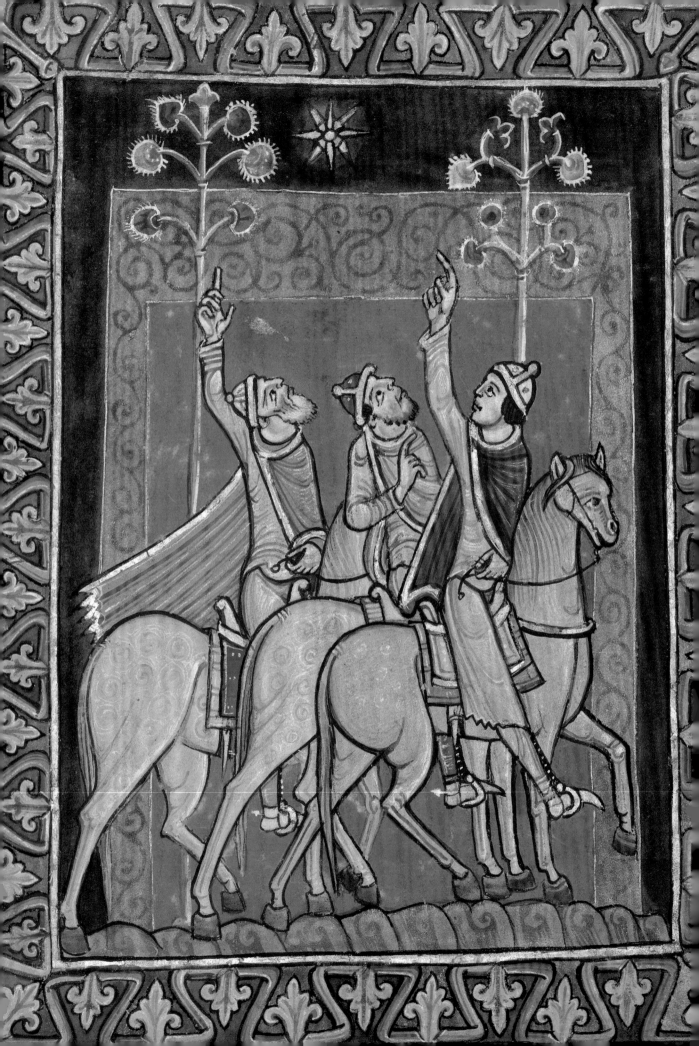

The St. Albans Psalter

Painting and Prayer in Medieval England

Kristen Collins, Peter Kidd, and Nancy K. Turner

THE J. PAUL GETTY MUSEUM • LOS ANGELES

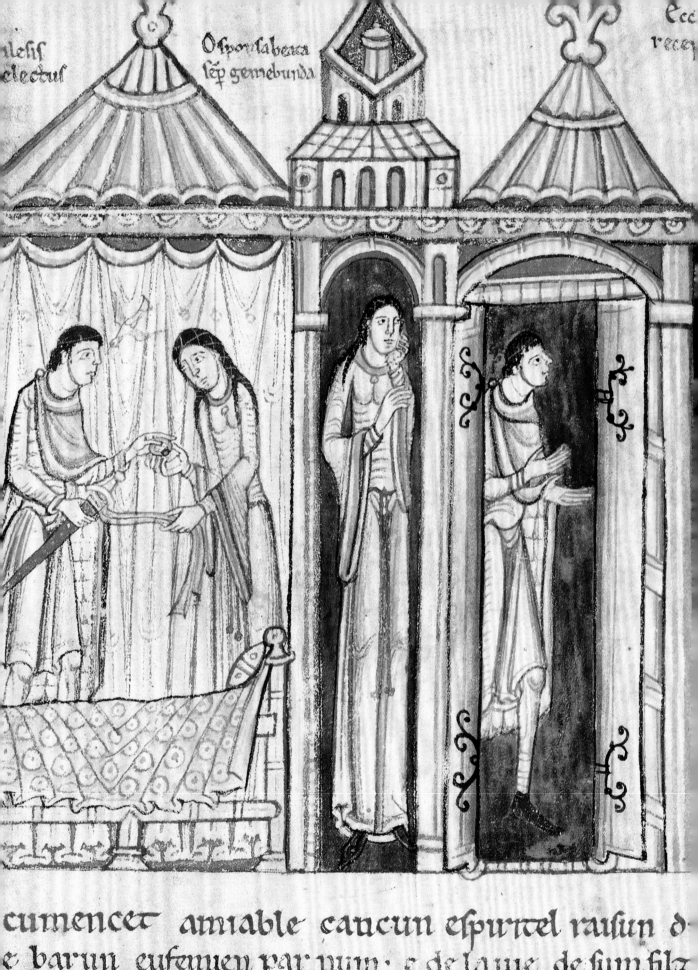

cumencet amiable caucun esp[ur]tel raisun d[e]
[e] barun eufemien par num. e de la vie de sun filz
[e]t del quel nus auum oit l[itt]re ex[an]ter. par num[e]
ent[e] il desurrables icel fil filz ingendr[er]...

Contents

Foreword

The St. Albans Psalter, created at St. Albans Abbey just north of London, is the earliest elaborately illuminated manuscript known from the years following the Norman Conquest and is considered by many to be the most beautiful and important illuminated manuscript to have survived from twelfth-century England. Its masterful paintings mark a decisive break from the earlier Anglo-Saxon style and herald the introduction of Romanesque painting to England.

The principal reason that some medieval manuscripts have survived the hazards of fire, war, and changing political circumstances is their portability and adaptability to new settings. However, it is not known precisely when nor how the St. Albans Psalter left England. The name of the pope has been erased in the manuscript's calendar section, suggesting that it was still in England during the Reformation, when England rejected the authority of Rome. It likely traveled to Germany with a group of English Benedictines who settled at Lamspringe, south of Hildesheim, in 1643. From there it passed to the Basilica of St. Godehard and now remains in the keeping of the Dombibliothek Hildesheim in Germany.

The generous loan of this splendid psalter to Los Angeles made possible this book and the associated exhibition *Canterbury and St. Albans: Treasures from Church and Cloister* at the J. Paul Getty Museum. The Getty Museum holds one of the finest collections of medieval and Renaissance manuscripts in the United States, and this exhibition is the latest in a series designed to raise public appreciation of these rare and precious works of art. Thanks to a rare alignment of opportunities, the exhibition presents the disbound St. Albans Psalter together with the monumental stained glass windows from Canterbury Cathedral showing life-size figures of Old Testament patriarchs as the Ancestors of Christ. Begun around 1178, these are among the earliest examples of English stained glass. Uniting the windows with the St. Albans Psalter makes possible an unprecedented display and investigation of twelfth-century English painting, ranging from the grand and public to the intimate and private. The windows are featured in another Getty publication, *The Ancestors of Christ Windows at Canterbury Cathedral.*

This exhibition and book would not have been possible without the extraordinary loan of the St. Albans Psalter granted by Bishop Norbert Trelle of Hildesheim and the Basilica of St. Godehard. We offer our deepest gratitude to Jochen Bepler, librarian of Dombibliothek Hildesheim, for his vision and commitment to making the psalter accessible for the first time to the American public. We also thank Gerhard Lutz at the Dom-Museum, Hildesheim, for his support.

The Getty likewise expresses its profound appreciation to the Very Reverend Robert Willis, Dean of Canterbury, as well as Brigadier John Meardon and Léonie Seliger for the exceptional loan of the Ancestors of Christ windows. Also vital to the success of this project were the other lending institutions, together with their directors and curators, and a private collector: Thomas Campbell and Peter Barnet at the Metropolitan Museum of Art, New York; Claire Ben Lakhdar-Kreuwen at the Bibliothèque de la codecom de Verdun; William Griswold and William Voelkle at the Morgan Library & Museum, New York; and Sir Paul Ruddock, London. We are grateful to Verlag Müller und Schindler for its generous provision of copies of its facsimile of the psalter for the exhibition.

Finally, we are grateful to the coauthors of this book: Kristen Collins, associate curator in the Getty's Department of Manuscripts; Nancy Turner, manuscripts conservator in the Department of Paper Conservation; and Peter Kidd, a former Getty Museum Scholar who has been actively researching the St. Albans Psalter since 1997. The authors have produced a study that presents both a broad overview of the psalter's history and context and a thorough physical examination of its material composition. Their research, together with that of the Getty Conservation Institute's Karen Trentelman and Lynn Lee, has managed to shed new light on this much-studied manuscript—no small feat in itself. This book shares the fruits of that research, and it is our hope that readers will gain a deeper understanding of this great work of English Romanesque manuscript illumination.

Timothy Potts
Director, The J. Paul Getty Museum

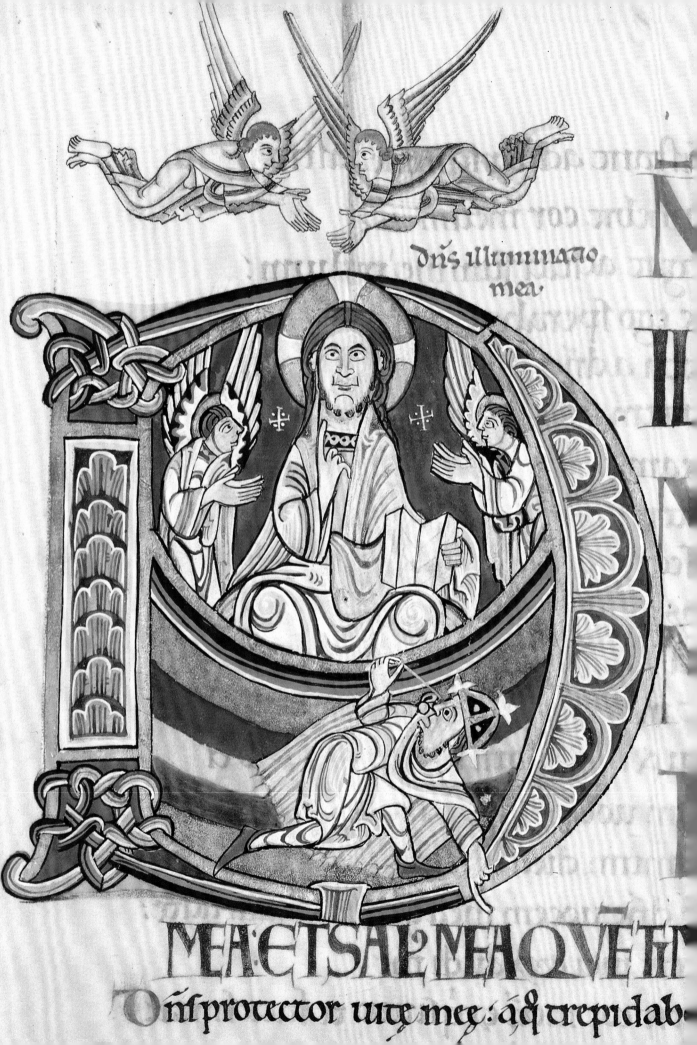

dñs illuminatio mea.

MEA ET SALVE MEA QVE

Dñs protector vite mee: a q̃ trepidab

Pictures and the Devotional Imagination in the St. Albans Psalter

Kristen Collins

THE ST. ALBANS PSALTER is one of the most important illuminated manuscripts from twelfth-century Europe. Created at St. Albans within a decade of 1130, the manuscript offers a marked contrast to the Anglo-Saxon works that preceded it. Its graceful, powerfully drawn figures and use of richly saturated colors signal the decisive arrival of the Romanesque style of illumination in England. Psalters such as this contain the 150 *psalmi* (Latin for "songs of praise") from the Old Testament book of Psalms as well as additional devotional materials.[1] For the better part of the Middle Ages, the psalter was the most frequently used personal prayer book for religious and laypeople alike. Although most early medieval prayer books were not illustrated, the St. Albans Psalter includes more than 40 full-page miniatures and 210 historiated initials (fig. 1).[2] Decorated with gold and luminous colors, the illuminations offer a luxurious visual display unparalleled in any surviving English manuscripts from this period. The book is prefaced by an extended cycle of full-page pictures of Old Testament scenes and events from the life of Christ (fig. 2). Devoid of text, these expressive images provided the reader with an imaginative entry into biblical history. The ornate initials enlivening the remainder of the manuscript contain pictures that give literal form to the complex and beautiful poetry of the psalms.

Fig. 1
Psalm 26, Initial *D*
St. Albans Psalter, p. 119

9

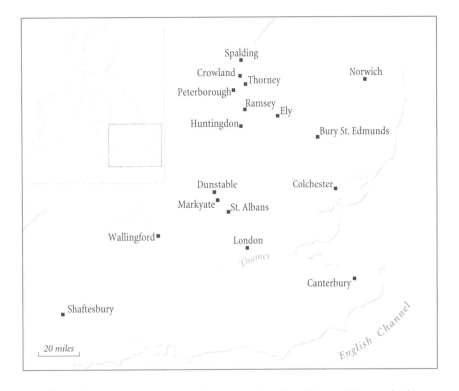

Fig. 2
The Adoration of the Magi
St. Albans Psalter, p. 25

Fig. 3
Map of Southeast England

Fig. 4
The Death of Harold
Bayeux Embroidery (detail)
Canterbury(?), England,
ca. 1077–82
Bayeux, Musée de la
Tapisserie de Bayeux

The psalter was written and illuminated at St. Albans Abbey, which was established in the eighth century on the site, about twenty-five miles north of London, where Alban, England's first saint, had been martyred by the Romans (fig. 3). Following the Norman Conquest, it became a significant center of manuscript production. The defeat of the Anglo-Saxon king Harold by Duke William of Normandy in 1066 (fig. 4) marked not only a political break from the old regime but an artistic and cultural transformation of English monasteries. St. Albans's first Norman abbot, Paul of Caen (d. 1093) arrived in 1077. Charged with sweeping away Anglo-Saxon tradition to make way for Norman

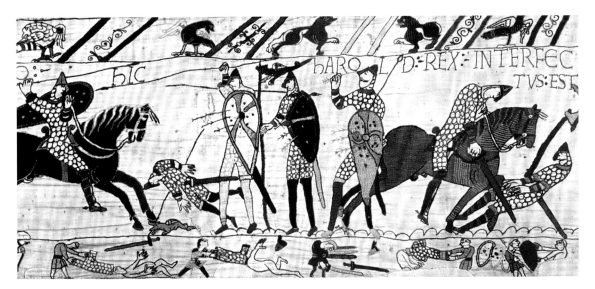

Fig. 5
Medieval Abbey Church
of St. Alban
St. Albans, England

reform, he was described in the monastery's *Gesta Abbatum* (Deeds of the abbots) as the "new broom."[3] Under his rule, new properties were acquired for the monastery, construction of the Romanesque abbey church was begun (fig. 5), and a scriptorium, staffed with professional scribes, was established for the creation of manuscripts for the community.[4] The first extant decorated manuscripts from St. Albans probably date to 1110–20 (fig. 6).[5]

The most accomplished artist to emerge from this period at St. Albans is known as the Alexis Master, so named for the illumination with scenes from the life of Saint Alexis in the manuscript. Several other miniatures from this section of the manuscript and its prefatory picture cycle have also been attributed to him. However, recent study suggests that these pictures were actually the work of two artists.[6] Ironically, the Alexis Master seems to have been responsible for all of the above-mentioned miniatures with the exception of the one containing the Alexis scenes for which he was named. His work in the prefatory cycle marks the emergence of a luminously colored, densely applied style of painting at the

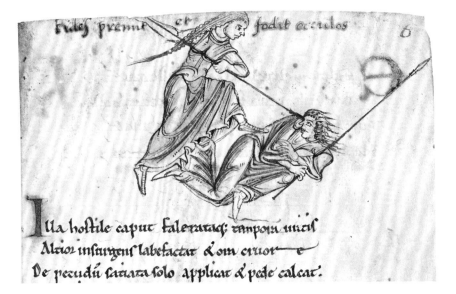

Fig. 6
Faith Killing Idolatry (detail)
Prudentius, *Psychomachia*
St. Albans, England,
ca. 1110–20
London, British Library,
Cotton Ms. Titus D.xvi,
fol. 6

monastery (fig. 7), an aesthetic found in the illuminated initials of the psalter section as well. The richly painted and saturated colors stand in stark contrast to the delicate color washes prevalent in late Anglo-Saxon illumination before the Norman Conquest (fig. 8). The novel artistic style of the St. Albans illuminations and the lack of similar examples with which to compare them have made it difficult to situate this manuscript within the greater timeline of English Romanesque painting. There is quite simply no other book from this period that matches the St. Albans Psalter in sophistication, inventiveness, or number of illustrations.

The date of the St. Albans Psalter is crucial because this psalter contains so many "firsts": the first example of a fully painted narrative picture cycle, the first examples of several iconographic motifs, and the first piece of literature in French. Each of these features is of such importance that scholars have made considerable effort to pin down the date of the book. It was long thought to date to about 1123, and yet within the past few years scholars have proposed dates as early as pre-1121 and as late as 1145.[7] This difference may seem trivial, especially as most twelfth-century manuscripts cannot reliably be dated to within a quarter century, but the earlier date would make the psalter even more precocious than is usually accepted, and the later one would turn other relationships on their head, for example by dating the psalter later than the Bury Bible of about 1130–35.[8] The authors of this volume believe that a date of about 1130 is plausible but that it should be taken as a midpoint of a broader range of possibilities, between about 1120 and about 1140.

This essay offers an introduction to the St. Albans Psalter, its history and material form, with commentary on its illuminations and reflections on the role of pictures in high medieval thought and devotion. The manuscript consists of five sections: a calendar with feast days and tables for computing the date of Easter; the prefatory cycle with biblical scenes; the Alexis Quire, containing

Following pages
Fig. 7
The Entombment of Christ
St. Albans Psalter, p. 48

Fig. 8
The Harrowing of Hell
Tiberius Psalter
Winchester, England,
after 1063
London, British Library,
Cotton Ms. Tiberius C.vi,
fol. 14

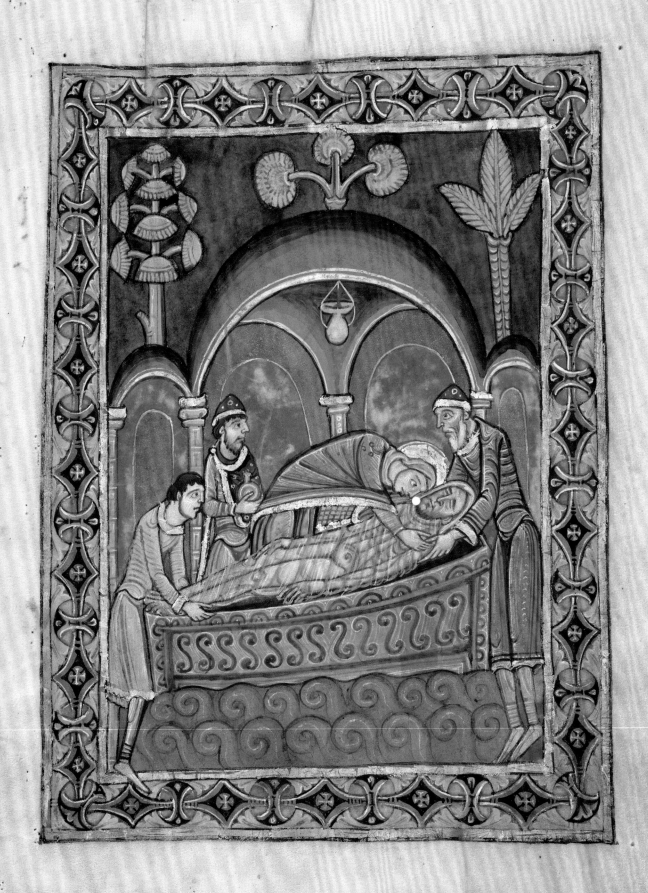

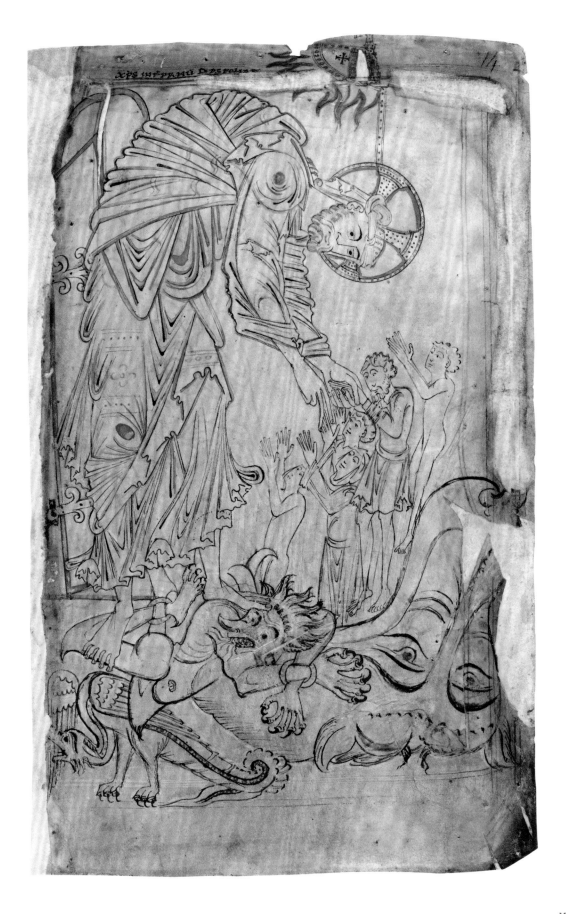

hagiographic and theological texts as well as pictures; the illuminated psalter with additional devotional materials; and two full-page illustrations of Saint Alban and King David. The varied decorative techniques and scribal hands in the five sections have led scholars to debate whether the manuscript was produced as a cohesive project by a group of individuals working at the same time or assembled gradually over an extended period. These possibilities are also considered here, as well as issues of patronage and readership, which, because of the manuscript's composite nature, remain a subject of ongoing debate.

What's in a Name?

The artistry of the St. Albans Psalter is singular; so too is the cult of personality that has developed around this book. It has become almost impossible to discuss the manuscript without invoking the two individuals thought to have commissioned and used it—Abbot Geoffrey of St. Albans and the anchoress Christina of Markyate. Since its first modern publication, the manuscript has usually been known as the *Albani* or the St. Albans Psalter, both titles that reference the place where it was created.[9] Recent studies, however, have preferred to name the book for Christina,[10] a close friend and adviser to Geoffrey Gorron, the Norman abbot of St. Albans who ruled from 1119 until his death in 1146. He is believed to have commissioned the psalter for her.

Geoffrey, a native of Gorron, France, was a secular clerk working in Le Mans when he was invited to become schoolmaster at St. Albans. Upon his somewhat delayed arrival, he found that position filled and took another in Dunstable instead. It was during this time that he borrowed several costly vestments from St. Albans as props for a miracle play he was producing. When a fire in his lodgings destroyed the vestments, Geoffrey made restitution to the abbey by entering the community as a monk. He rose through the ranks, being appointed prior and then abbot. His abbacy was characterized by new contributions to the liturgy, patronage of the arts, and care for the poor.

Christina of Markyate was a onetime recluse who established a small community of religious women at Markyate, on the borders of St. Albans's properties. That we possess the considerable degree of knowledge that we do about her life and visions is largely a matter of luck. Christina's *vita* (or biography) survives in just one manuscript that narrowly escaped being destroyed by fire in 1731.[11] Through this account, we are privy to knowledge of Christina's childhood desire to enter monastic orders. The daughter of an upper-class Anglo-Saxon family, Christina was born in Huntingdon (see fig. 3). Her life as a recluse was a matter not so much of choice as of necessity. Forced into marriage by her parents around the age of seventeen, she nevertheless refused to consummate the union, lecturing her husband, Burthred, on the virtues of a chaste life. When he rejected her proposal that they both enter religious orders, she fled and went into hiding for a number of years. She eventually came to Markyate, where she lived under the

Fig. 9

Calendar Page for December (detail of the obit of Christina of Markyate, visible at bottom right)

St. Albans Psalter, p. 14

protection of Roger the Hermit, a St. Albans monk who lived apart from the community. She remained hidden by day in a small shed next to Roger's cell until her marriage was finally annulled. Leaving for a brief time after Roger's death, around 1121–22, Christina returned to live at Markyate with a small group of women.

It is not clear when Christina met Geoffrey, but it was probably around 1130.[12] Her friendship with the abbot in many ways broke from the traditional model of the male cleric who provided spiritual guidance for women who had withdrawn from the world.[13] Instead, the anchoress served as the adviser, providing guidance and redirection—and even undergarments—for the abbot. (Called to make the arduous journey to Rome, Geoffrey asked Christina to supply him with articles of clothing that would "mitigate the hardship of the journey."[14]) Their relationship began when Christina cautioned him against a particular course of action upon which he had decided. Although initially skeptical, he came to value her counsel and their friendship. Christina's *vita* was likely commissioned by Geoffrey to enhance the standing of St. Albans as a holy site. Association with holy figures, particularly recluses, would do much to elevate the status of the primary institution, as evidenced at St. Albans by the entombment of the hermits Roger and Sigar within the abbey church.[15]

The *vita* makes no mention of the gift of an illuminated psalter to Christina. The definitive connection between the anchoress and the psalter is found in the psalter's calendar, where obits record her death date along with those of her family members and associates (fig. 9). Written in a hand later than that of the primary

Fig. 10
Psalm 105, Initial *C*
(Christina Initial)
St. Albans Psalter, p. 285

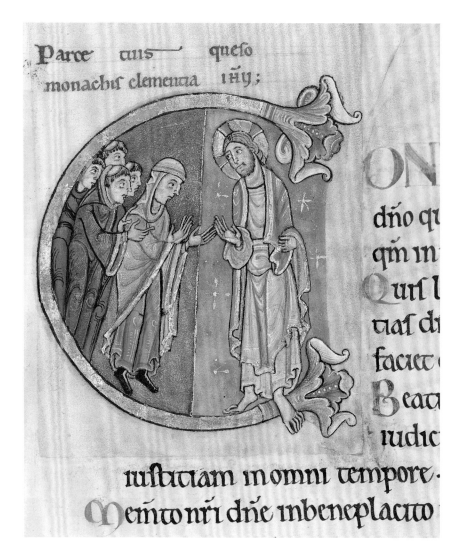

calendar scribe, these obits make it clear that at some point in the decades after the creation of the manuscript it became a means of memorializing her. The psalter also contains an image that is almost certainly intended to link the book to Christina. A pasted-in miniature replaces the original initial for Psalm 105, which begins with the words "Confitemini Domino" (Give praise to the Lord) (fig. 10).[16] An initial *C* (also the initial for Christina's name) encloses a scene in which a nun intercedes with Christ on behalf of monks who stand behind her. The rubric (a heading, here written in red and green), in a hand different from any other in the manuscript, is the only one in the psalter that does not repeat a line from the accompanying psalm. It reads, "Spare your monks, I beseech you, oh merciful kindness of Jesus." The style indicates that the replacement initial was created slightly later than the manuscript, but how much later is not clear.

The image, which shows Christina standing in the earthly green zone of the initial and reaching with one hand into the celestial blue space occupied by Christ, is usually interpreted as a reflection of her active role as a holy woman

and conduit to the divine. As one who experienced visions, which she shared with the abbot, Christina mediated between the earthly and heavenly realms. The gestures of the monk closest to her could support an interpretation of the picture as a posthumous addition, however. He rests one hand on her back and raises another in the gesture of speech to Christ, as if commending Christina—her hands raised in a gesture of prayer—into his care. It is possible, then, that the pasted-in initial was added as a way of memorializing Christina after her death, sometime after 1155.[17]

Close physical examination of the manuscript has revealed little evidence to shed light on when—either during the production process or long after—the initial was added. The traditional and prevailing argument has held that the St. Albans Psalter was commissioned specifically for Christina's personal use.[18] The pictures and prayers of the psalter have, in varying degrees, been interpreted as reflections of Christina's visions and experiences, formulated for her readership. Ultimately, however, it remains a question whether she was the intended recipient of the luxurious manuscript or whether it was created for another member of the abbey while reflecting her relationship with the institution and its abbot.[19] Christina's presence in the local community might explain her resonance throughout the manuscript—in the obits, in the so-called Christina Initial, and perhaps in some of the manuscript's images of women—even if the book was not commissioned specifically as a gift for her.[20] A recent study of the psalter by Rodney M. Thomson has suggested that such a richly illustrated and costly book would more likely have been owned by Christina's friend and benefactor, Abbot Geoffrey.[21] Thomson advances the argument by noting that the Alexis Quire—a slightly esoteric and eclectic document including hagiographic and theological materials—seems more in line with something that would be owned by an abbot than by an anchoress of dubious literacy.[22]

Although her *vita* provides a tantalizing degree of information about her, Christina and her story have in some ways come to overshadow the study of the psalter that may or may not have been created for her use. The *vita* has at times been used by scholars as the starting point to prove that the psalter was created specifically for the anchoress. More work remains to be done on the issue of female readership and the St. Albans Psalter. A closer examination of the saints in the calendar and litany contextualized within a broader study of devotional trends in twelfth-century England will perhaps reveal whether the contents of this book display a geographic or gender bias that will strengthen the argument that the book was designed for Christina.[23] Until more definitive evidence linking the commission of the manuscript with the anchoress can be provided, perhaps a more cautious recognition of the book's connection to her would be to refer to it as "The Christina of Markyate Psalter." Such a title would acknowledge it as an object used to preserve Christina's memory but would also allow that much about its origins and ownership remains unknown.

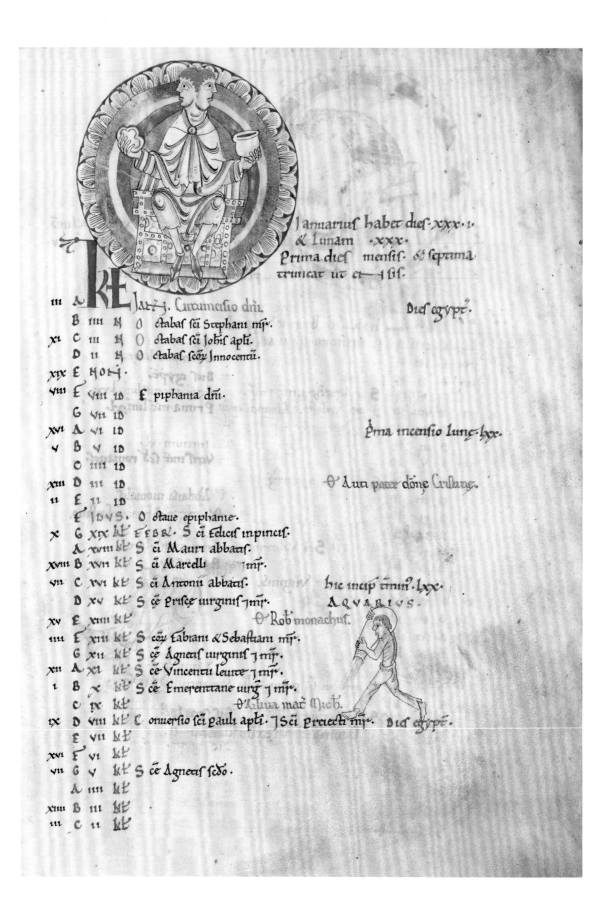

Januarius habet dies · xxx · i ·
& lunam · xxx ·
Prima dies mensis · & septima
truncat ut ex — i sis.

iii	A			Jan 7. Circumcisio dni.		Dies egypt.
	B	iiii	N	O ctabas sci Stephani mr.		
xi	C	iii	N	O ctabas sci Iohis apli.		
	D	ii	N	O ctabas scor Innocentu.		
xix	E	N O N j.				
viii	F	viii	ID	E piphania dni.		
	G	vii	ID			
xvi	A	vi	ID			prima incensio lune · lxx ·
v	B	v	ID			
	C	iiii	ID			
xiii	D	iii	ID			O Luci pater done Cristiane
ii	E	ii	ID			
	F	IDVS.		O ctaue epiphanie.		
x	G	xix	KL	F E B R. S ci Felicis in pincis.		
	A	xviii	KL	S ci Mauri abbatis.		
xviii	B	xvii	KL	S ci Marcelli mr.		
vii	C	xvi	KL	S ci Antonii abbatis.		hic incip trinu. lxx.
	D	xv	KL	S ce Prisce uirginis j mr.		AQVARIVS.
xv	E	xiiii	KL		O Rob monachus.	
iiii	F	xiii	KL	S cor Fabiani & Sebastiani mr.		
	G	xii	KL	S ce Agnetis uirginis j mr.		
xii	A	xi	KL	S ce Vincentii leuite j mr.		
i	B	x	KL	S ce Emerentiane uirg j mr.		
	C	ix	KL		O Liuua mat Mich.	
ix	D	viii	KL	C onuersio sci pauli apli. j Sci Preiecti mr.		Dies egypt.
	E	vii	KL			
xvi	F	vi	KL			
vii	G	v	KL	S ce Agnetis scdo.		
	A	iiii	KL			
xiiii	B	iii	KL			
iii	C	ii	KL			

The Parts of the Manuscript

The Calendar | The first eight leaves of the St. Albans Psalter contain a calendar and associated material. Each month is illustrated with a roundel at the top of the page containing a figure representing an occupation associated with that month; elsewhere on the page is a corresponding personification of an astrological symbol. For example, January, the month of feasting, is represented by the two-faced Roman god Janus, who holds a drinking cup in one hand (fig. 11). Below, a figure pouring water from a pitcher personifies the zodiac sign for Aquarius. For August, the harvest month, the seated figure in the roundel holds a sheaf of corn (fig. 12). The figure of Virgo, below, is larger than any of the other zodiacal signs: her halo suggests that she is here conflated with the Virgin Mary, whose feast of the Assumption falls on August 15. The occupations of the month and astrological signs were similarly paired on the sculpted facades of churches in the twelfth century. The passage of time was thus represented with a combined imagery of the rural labors that governed the lives of medieval people and the scientific method they used to order their years.[24]

The images in this section of the St. Albans Psalter are painted with delicate color washes. To the modern viewer, the tinted drawings in the calendar and the Alexis Quire may seem stylistically at odds with the richly saturated illuminations in the manuscript's prefatory cycle and psalter proper. Recent studies have demonstrated, however, that the Calendar Artist was also responsible for the underdrawings for the decorated psalm initials.[25]

Beginning with January, the scribe entered saints' feast days in brown ink, distinguishing certain important days with capital letters, and from March onward, through the use of blue, red, and green inks. As documents containing feast days for specific saints or the death dates of family members and associates, medieval calendars often provide clues to a manuscript's owners or place of origin. Thus it is puzzling that the St. Albans Psalter does not include numerous entries relevant to St. Albans.[26] One would expect that a calendar made at St. Albans Abbey would contain in its roster of holy days mention of important feasts for the monastery. While the calendar does include two feasts for Saint Alban—his death day and the invention (or discovery) of his relics—it also includes a number of feasts associated with Ramsey Abbey, an institution located in the region near Huntingdon, where Christina was raised. The eclectic nature of the calendar is probably a result of the manuscript's status as a personal, not institutional, prayer book. Whether owned by Christina or by Geoffrey, it was not intended for the general use of the community; as a personal prayer book, it could feature a customized group of saints and feasts.

One of the most personalized aspects of the calendar is found in the unusually long obit for Roger the Hermit, the monk who provided Christina with shelter and spiritual guidance when she fled her forced marriage. Roger was held

Fig. 11
Calendar Page for January
St. Albans Psalter, p. 3

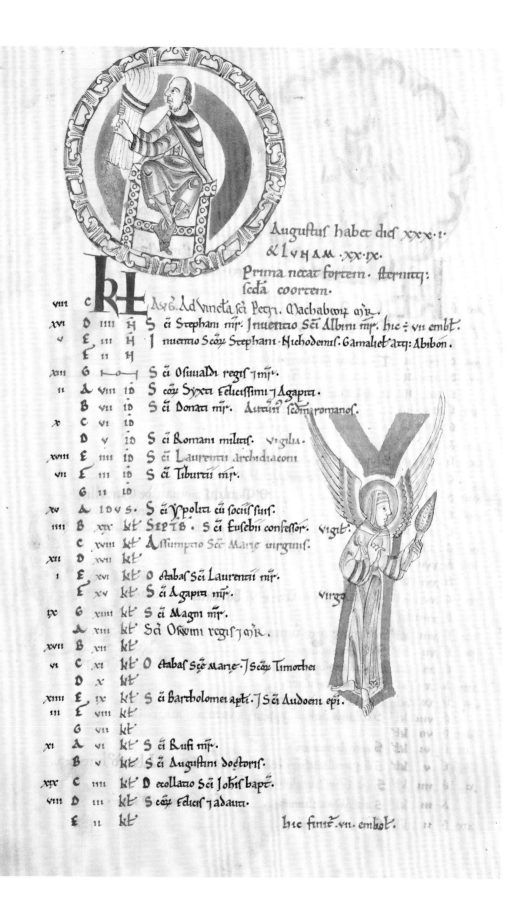

Augustus habet dies xxx.i.
& Lunam xx.ix.
Prima necat fortem. sternitq:
seda coortem.

viii	c			Aug. Ad Vincla sci Petri. Machabeoru m'r.
xvi	D	iiii	N	S cū Stephani m'r. Inuentio Sci Albini m'r. hic ÷ vii embt
v	E	iii	N	I inuentio Scōz Stephani. Nichodemis. Gamaliel atq: Abibon.
	F	ii	N	
xiii	G			S cū Osuualdi regis 7 m'r.
ii	A	viii	ID	S cōz Sixti Felicissimi 7 Agapiti.
	B	vii	ID	S cū Donati m'r. Auciui seding romanos.
x	C	vi	ID	
	D	v	ID	S cū Romani militis. vigilia.
xviii	E	iiii	ID	S cū Laurentii archidiaconi
vii	F	iii	ID	S cū Tiburtii m'r.
	G	ii	ID	
xv	A	ID	S.	S cū Ypoliti cū sociis suis.
iiii	B	xix	kt	SEPTB. S cū Eusebii confessor. vigil.
	C	xviii	kt	Assumpcio Scē Marie uirginis.
xii	D	xvii	kt	
i	E	xvi	kt	O ctabas Sci Laurentii m'r.
	F	xv	kt	S cū Agapiti m'r.
ix	G	xiiii	kt	S cū Magni m'r.
	A	xiii	kt	Scī Osuuini regis 7 m'r.
xvii	B	xii	kt	
vi	C	xi	kt	O ctabas Scē Marie. 7 Scōz Timothei
	D	x	kt	
xiiii	E	ix	kt	S cū Bartholomei apti. 7 S cū Audoeni epi.
iii	F	viii	kt	
	G	vii	kt	
xi	A	vi	kt	S cū Rufi m'r.
	B	v	kt	S cū Augustini doctoris.
xix	C	iiii	kt	Decollacio Sci Johis bapt.
viii	D	iii	kt	S cōz Felicis 7 adaucti.
	E	ii	kt	

virgo

hic finit vii embol.

as a holy man and exemplar by the monks of St. Albans as well as by the larger ecclesiastical community. After the calendar was completed, a second scribe added the obit, which reads, "The death of Roger the hermit monk of St. Albans. Whosoever shall have this Psalter, keep his memory especially on this day."[27]

As noted above, the calendar also contains, entered in a third hand, the obits for Christina of Markyate (see fig. 9), members of her family, and her associates. The inscriptions appear in a variety of inks, suggesting that they were added over a period of time. The question that remains is whether the obits were added as a consequence of Christina's ownership, at the request of members of her community at Markyate, or by a subsequent abbot, Geoffrey's nephew, Robert de Gorron (r. 1151–66), who may have had an interest in promoting her as a local saint, much like Roger and Sigar.

The Prefatory Cycle | Following the calendar section, forty full-page pictures function as a preface to the psalms themselves. Showing primarily christological scenes, the pictures act as visual Gospels. They function as a symbolic bridge to the psalms and underscore the medieval Christian belief that all Old Testament prophecy was fulfilled in Christ.[28] They also act as independent devotional aids, meant to encourage meditation on the life of Christ.[29]

The practice of prefacing a book of Psalms with full-page pictures had a precedent in England.[30] The Tiberius Psalter, from the late eleventh century, contains twenty-four tinted drawings of the life of Christ (see fig. 8), King David, and the Archangel Michael.[31] The charged and energetic line drawings, with their colored outlines and agitated, fluttering garments, are masterpieces of the style that characterized the Winchester school of Anglo-Saxon illumination.

The opaquely painted, richly colored pictures of the St. Albans prefatory cycle, executed by the Alexis Master, usher in an aesthetic quite distinct from that of illumination around the time of the Conquest. In the Alexis Master's works, the agitated flutter of Anglo-Saxon drapery gives way to a quieter, more monumental art. His figures are characterized by faces shown in profile and by elongated, graceful forms, clothed in sculptural draperies that are carefully compartmentalized so as to delineate the anatomies below.

In contrast to the undefined and ethereal backgrounds of Anglo-Saxon manuscripts, the figures in the St. Albans prefatory cycle move through structured zones of the page. Architectural forms and color fields focus the eye and inform the viewer of key interactive moments. These are not illusionistic spaces so much as staging devices that allowed the artist to emphasize moments of speech and action. In *The Annunciation to the Shepherds*, the space in which the angel appears is bound by a curving border of green that forms a kind of full-body speech bubble (fig. 13); in *The Magi before Herod*, the Three Kings stand within conjoined arches of blue on a green field (fig. 14). Whereas later in twelfth-century manuscript illumination speech moments are announced through unfurled

Fig. 12
Calendar Page for August
St. Albans Psalter, p. 10

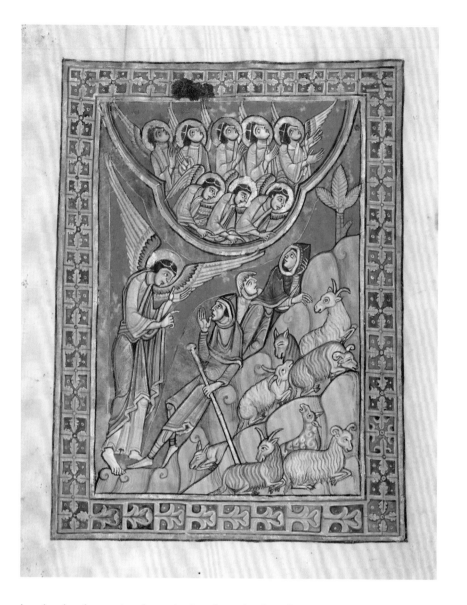

banderoles that spring from the hand, in the St. Albans picture cycle moments of speech and hearing are announced through the curving index finger and the outstretched hand (fig. 15).[32]

Reinforcing its role as bridge between the Old and New Testaments, the prefatory cycle actually begins with two Old Testament scenes, *The Fall* and *The Expulsion from Paradise* (fig. 16). These are followed by scenes from the infancy, ministry, and Passion of Christ. In keeping with the new Romanesque aesthetic, the curving forms of the figures' bodies lend an almost balletic quality to the scenes, imbuing the slightest gesture with added emphasis. In *The Betrayal*, Christ sways passively toward Judas, the slope of his body echoed exactly by that of the apostle who rushes to identify him to the waiting soldiers (fig. 17). Painted in richly saturated hues, the individual scenes are banded with ornate frames in foliate and interlace patterns.

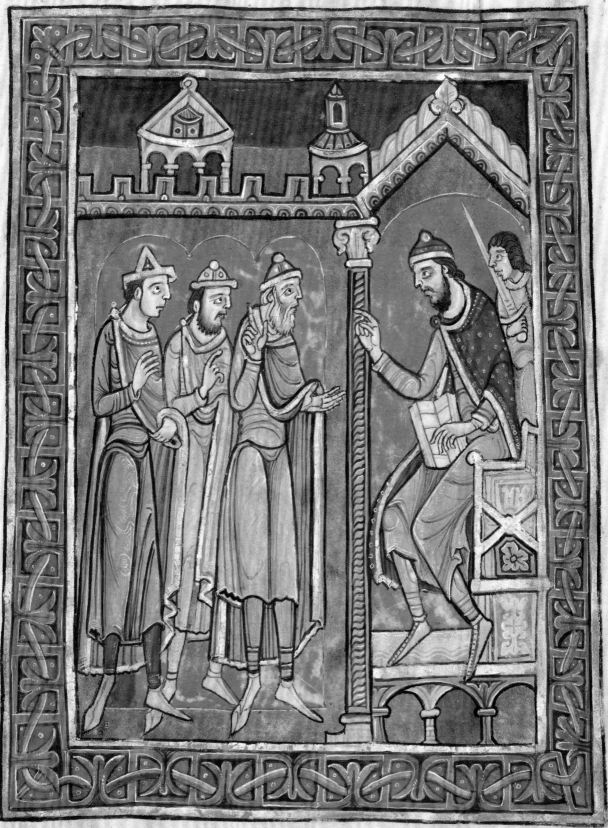

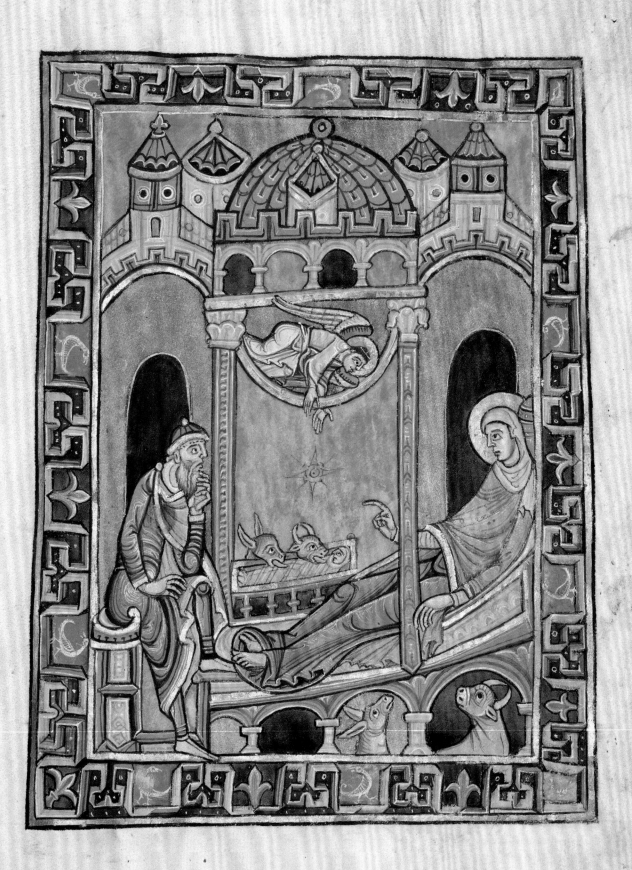

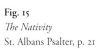

Fig. 15
The Nativity
St. Albans Psalter, p. 21

Fig. 16
The Expulsion from Paradise
St. Albans Psalter, p. 18

The entire cycle is characterized by a repetitive symmetry in which the Holy Family is shown on their flight into Egypt and on their return, and the Magi travel to Bethlehem and then depart. There are even two scenes for Christ's Agony in the Garden, one in which Christ ascends the Mount of Olives (fig. 18) and the other in which he descends to wake the apostles.[33] These last images, both of which show a chalice surmounted by a cross on the hilltop, provide the earliest example of the visual translation of Christ's words "My father, if it be possible, let this chalice pass from me" (Matt. 26:39). This image is also found in the manuscript's psalter section, in which Psalm 101, beginning "Lord hear my prayer," is interpreted in terms of Christ's prayer in the Garden of Gethsemane (fig. 19).

Earlier studies have implied that the painter's decision to create two images dedicated to the Agony in the Garden was unusual. Yet, as is so often the case with the St. Albans Psalter, the determination of what is "usual" is complicated

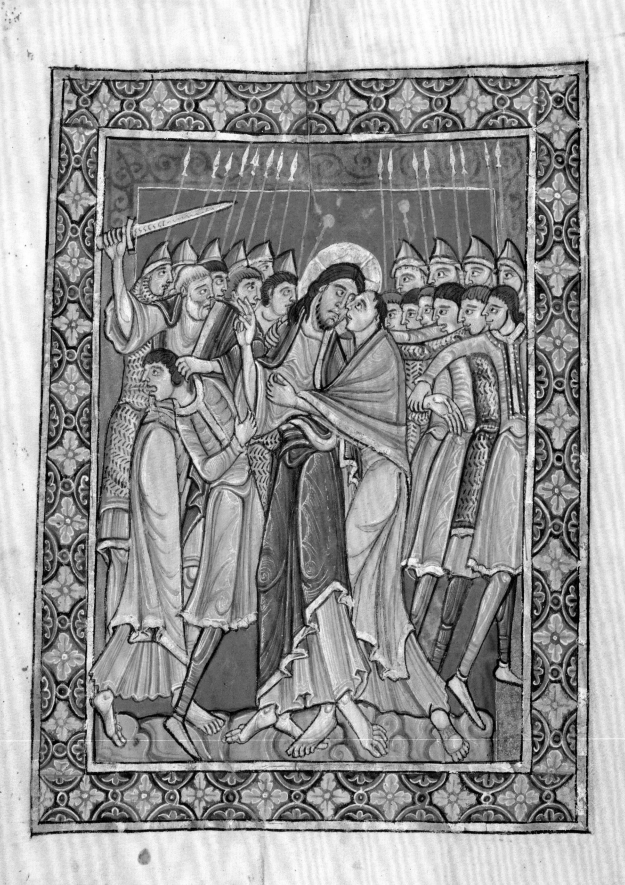

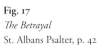

Fig. 17
The Betrayal
St. Albans Psalter, p. 42

Fig. 18
The Agony in the Garden
St. Albans Psalter, p. 39

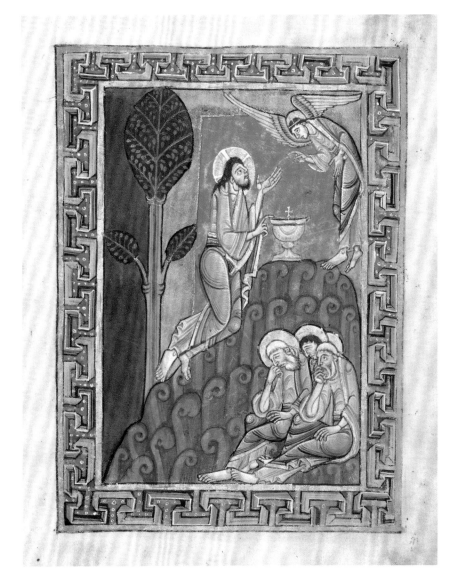

by the fact that there are no contemporaneous manuscript programs with which to compare it.[34] There are, however, examples of the split scene in sculptural programs from the period. A cloister capital from La Daurade in Toulouse, of about 1120–30, contains a capital with separate scenes: *Christ Praying* and *Christ Rousing the Disciples*.[35] Similarly, a capital from a now-destroyed cloister in Pamplona Cathedral, of about 1145, includes the image *Mary Magdalene Announcing the Resurrection to the Disciples* (fig. 20), one of the images that has consistently been noted in the St. Albans Psalter as a rarefied iconographic choice.[36] It is perhaps useful to remember that at precisely this moment across the Channel, in the sculptural programs of cloisters and church facades, there was a similarly impressive burst of narrative imagery. One cannot discount the effect that visual sources on the Continent, particularly sculptural programs, may have had on English book illumination.[37]

Fig. 19
Psalm 101, Initial *D*
St. Albans Psalter, p. 270

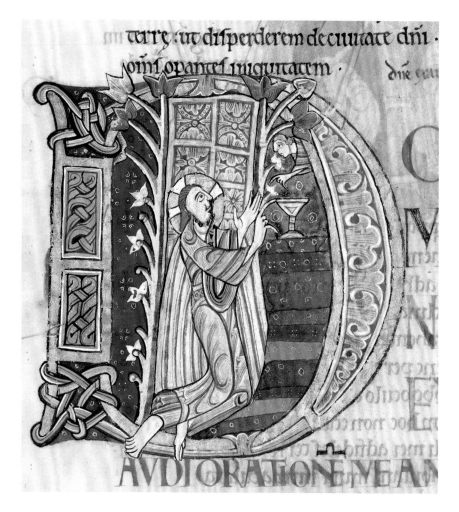

The prominence of Mary Magdalene in the picture cycle is one of the factors that has been interpreted as an indicator that the book's imagery was tailored for Christina, who would have identified with this most famous female disciple of Christ. In addition to the image *Mary Magdalene Announcing the Resurrection to the Disciples* (fig. 21), the picture cycle contains an image of Mary Magdalene washing Christ's feet in the house of the Pharisee as well as several group images thought to include her (*The Women at the Tomb* and *The Deposition*). Taken together, these pictures do indeed demonstrate an emphasis on Christ's female disciple in the psalter and could be seen as a reflection of Christina's relationship with the abbot of St. Albans. As one who experienced visions that she shared with Abbot Geoffrey, she, like Mary Magdalene, served as an intermediary of Christ. Most scholars have acknowledged, however, that such images could have functioned on several levels. The prominence of the female disciple does not necessarily indicate that the book was created for Christina's personal ownership but may merely suggest that it was created with her in mind,[38] reflecting the relationship from Geoffrey's perspective and for his readership. More generally, it could also reflect the growing role of Mary Magdalene in high medieval spir-

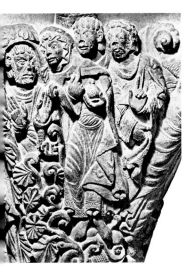

ituality. In France, church dedications to Mary Magdalene proliferated in the twelfth century.[39] Identification with the female disciple was not restricted to female religious; it also provided male monastics with an avenue to the heightened emotionalism sought after in the devotional practices of the twelfth century.

One of the great curiosities of the prefatory cycle is the lack of a conventional Crucifixion scene. In what is perhaps the most dynamic double-page opening in the book, Christ is seen on the left page energetically striding forward as he carries the Cross on his back (fig. 22). On the page to the right, the green-hued and slumped body of Christ is sorrowfully lowered from the Cross by Joseph of Arimathea (fig. 23). The Virgin and John hold Christ's limp hands to their faces, while a figure below uses pincers to remove the nail from Christ's foot. No image of the Crucifixion intervenes; nor is there physical evidence that an image was removed from this position in the book.

Fig. 20
Mary Magdalene Announcing the Resurrection to the Disciples
Cloister capital, Pamplona Cathedral
Pamplona, Spain, ca. 1145
Pamplona, Museo de Navarra

Fig. 21
Mary Magdalene Announcing the Resurrection to the Disciples
St. Albans Psalter, p. 51

Following pages
Fig. 22
Christ Carrying the Cross
St. Albans Psalter, p. 46

Fig. 23
The Descent from the Cross
St. Albans Psalter, p. 47

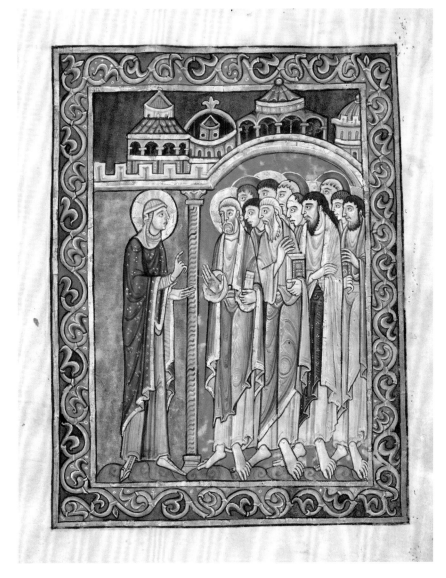

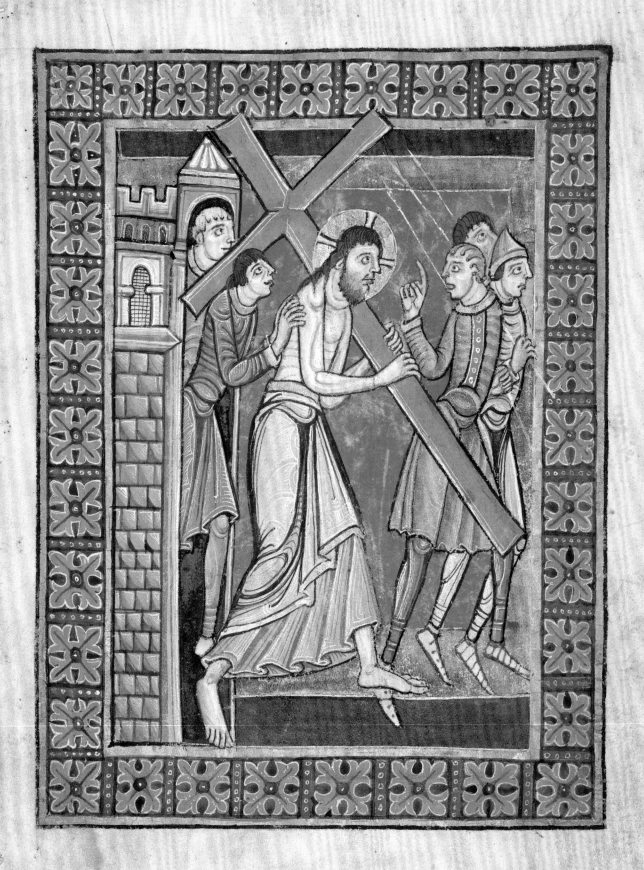

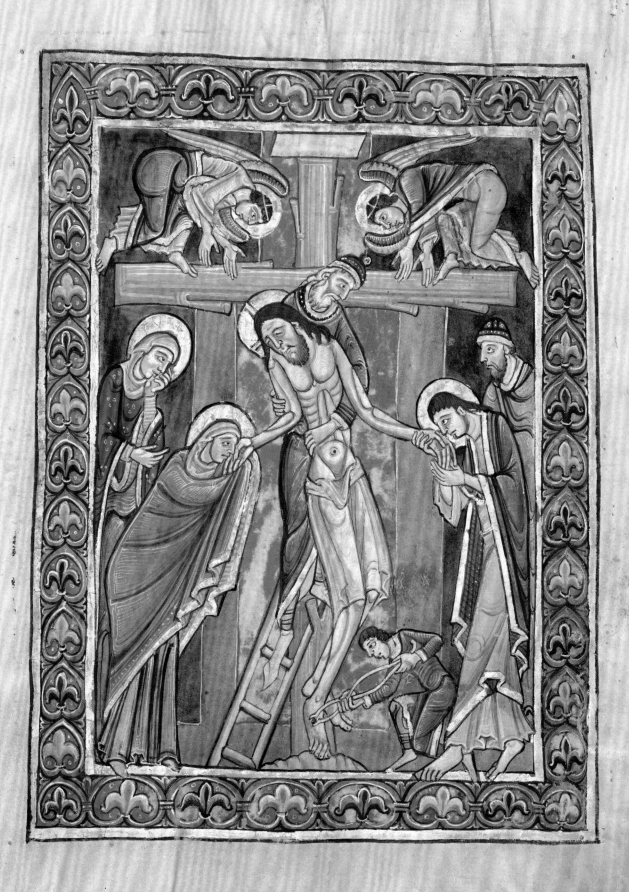

The lack of a Crucifixion scene, in many ways the central image for the Christian Church, has led scholars in the past to hypothesize that the psalter was intended to be read in the presence of such an image or that the book may have included an elaborate cover with the crucified Christ rendered in ivory or metalwork.[40] While the original cover of the St. Albans Psalter has long since disappeared, the sculptural programs in Romanesque churches offer a reminder of ways that art objects worked programmatically. Capital sculpture located on church interiors often omitted the Crucifixion, which would have been present above the main altar of the church.[41] Likewise, Crucifixions were seldom depicted on church facades during this period. It is possible that the book's reader was intended to use the book in proximity to a Crucifixion image that would have made the inclusion of such a scene in the prefatory cycle unnecessary.

Fig. 24
The Legend of Saint Martin
St. Albans Psalter, p. 53

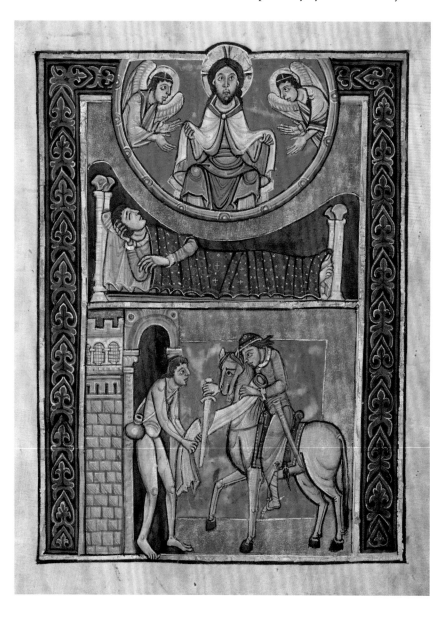

Alternatively, the choice to include the pathos of a Deposition scene in lieu of a Crucifixion scene could simply have reflected the growing emphasis on the suffering Christ, whose broken body became the focus of increasingly personalized prayers during this period.[42] In many of these prayers the devotee was urged to internalize Christ's experience on the Cross. For example, in the late eleventh century, Peter Damian (ca. 1072/73) urged the nun Agnes to envision Christ's Passion as a sachet of myrrh to be worn over the heart, explaining, "What is signified by myrrh, a kind of bitter spice with which the bodies of the dead are conditioned, unless it be the passion of Christ?"[43] Peter, a monk, and later a cardinal known for his sermons and writings, wrote further that through continual meditation on Christ's suffering, Agnes could bring Christ into her heart. Thus the lack of a Crucifixion scene may reflect an expectation that Passion devotion should be internalized. Elsewhere, Peter wrote of his desire to make visible "to the eyes of my soul Jesus Christ hanging upon the cross, pierced by nails."[44] It may be that at that point in the picture cycle, the reader-viewer was meant to experience the moment of Christ's death as a mental rather than a physical image.[45]

Ultimately, however, one must take care not to measure the St. Albans prefatory cycle against Passion cycles that followed later in the twelfth century. At this early point in the development of such picture cycles, the viewer may not have shared the modern expectation of a comprehensive or even a linear narrative. That narrative structure may have been disregarded is supported by the fact that some of the critical scenes are out of order. *The Agony in the Garden*, for example, appears before, rather than after, *The Last Supper*.[46] Although the modern viewer is conditioned to expect the Crucifixion as the ultimate representation of Christian salvation, the twelfth-century reader may not have considered its physical representation essential in this format.

The only image in the prefatory cycle to deviate from biblical narrative is that representing the miracle of Saint Martin (fig. 24). It is also the only hagiographic scene in this section of the manuscript. Saint Martin of Tours was a Roman soldier who cut his cloak in half to share it with a beggar. Later, Martin had a vision of Christ, who came to him in a dream wearing the cloak. This is the only double-tiered image in the cycle and appears to follow closely a format used in early-twelfth-century lives of Saint Martin, as can be seen in an image from a copy of the saint's life dating to after 1102 (fig. 25).[47]

Appearing between *Doubting Thomas* and *The Ascension*, *The Legend of Saint Martin* occupies the position one would expect to find occupied by scenes of Christ at Emmaus, which are pictured later in the manuscript, in the

Fig. 25
The Legend of Saint Martin
Richer of Metz, *Vita Sancti Martini*, after 1102
Trier, Stadtbibliothek, Hs 1378/103, fol. 132v

Alexis Quire. Martin, who shares his cloak with a beggar, failing to recognize him as Christ, thematically mirrors the disciples at Emmaus, who do not recognize Christ after his Resurrection.[48] They realize the identity of the pilgrim with whom they had been dining only after Christ's blessing of the bread, just before his miraculous disappearance from the room (see fig. 28). Similarly, Martin does not know Christ while in his physical presence but is able to perceive him only through a mystical event. As Magdalena Elizabeth Carrasco has noted, "The theme of witness, by sight, touch or by a dream or spiritual vision, is of central concern in the Psalter."[49]

Saint Martin would likely have had a personal significance for Abbot Geoffrey. Geoffrey's hometown of Gorron had a church dedicated to Martin, and it is conceivable that he would have requested the inclusion of this saint when commissioning the manuscript.[50] As a figure revered for his acts of charity, Martin may have been a thematically as well as geographically appropriate saint for Geoffrey. The *Gesta Abbatum* documents the abbot's own acts of charity—for example, redirecting funds to the foundation of Markyate, twice rebuilding it after fires—even while making it clear that they were not met with universal approval in the St. Albans community.[51]

The Alexis Quire | The Alexis Quire is a discrete booklet in the St. Albans Psalter. It takes its name from the miniature and accompanying poem about Saint Alexis that occupy the first twelve of its sixteen pages. Positioned between the prefatory cycle and the text of the psalms, this section of the manuscript has been seen by many scholars as the keystone for understanding the book as a whole, its texts and pictures providing an interpretive lens for the materials with which it was bound. Others have argued that the quire served as an autonomous booklet that was only later bound with the psalter.[52] In either case, its contents are puzzlingly eclectic. The quire contains the earliest known copy of the *Chanson de Saint Alexis*, a poem about the life of a saint venerated on the Continent but only newly introduced to England in the twelfth century.[53] It is written in Old French and introduced by a unique prologue written in Anglo-Norman, an insular dialect of French that developed following the Conquest. The quire also contains a paraphrase of Pope Gregory the Great's (r. 590–604) letter on the defense of images, which is first supplied in Latin and then repeated in Old French. These texts are followed by three images of Christ's encounters with the disciples at Emmaus after his Resurrection, a text on spiritual battle, and an illuminated initial *B* that begins the opening words of the first psalm.

The quire's first miniature shows several scenes from the story of the Roman saint known as the Blessed Alexis (fig. 26). Among his many pious acts, Alexis had put aside his marriage for a life of asceticism and poverty. Latin captions identify the figures who move across the page from left to right. After first lecturing his bride on the transience of earthly life and love, Alexis presents her with a sword

Fig. 26
*Scenes from the Life of
Saint Alexis*
St. Albans Psalter, p. 57

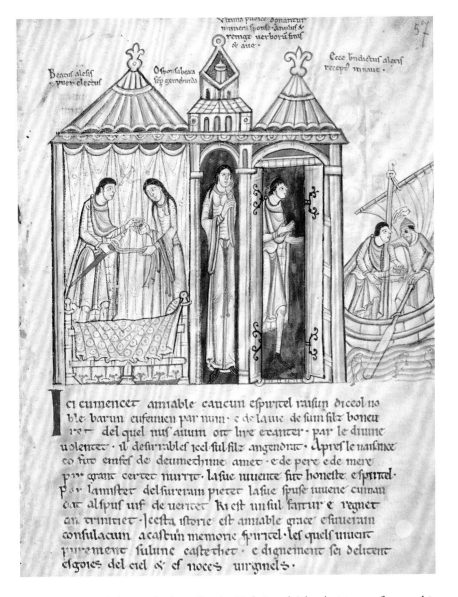

belt and ring and departs by boat for the Holy Land. The decision to feature this aspect of Alexis's tale (specifically, his unconsummated marriage) has often been interpreted as a deliberate reference to Christina of Markyate's marital situation.[54]

While Alexis's life could be understood as a mirror for Christina and her experiences, Alexis was also a saint significant for the larger community at St. Albans; a chapel there had been dedicated to Alexis during the rule of Abbot Richard (r. 1097–1119). It is possible that this quire may have been created as a hagiographic booklet for use in the chapel.[55] The text of the prologue starts, "Here begins the pious song and pious account of that noble lord Euphemien and his blessed son about whom we have heard readings and song." Monks may have read aloud from the booklet on the saint's feast day or during pilgrims' visits.[56]

The *chanson* is followed by a collection of texts and images that remove the quire from the genre of saints' lives and place it in the realm of a personalized

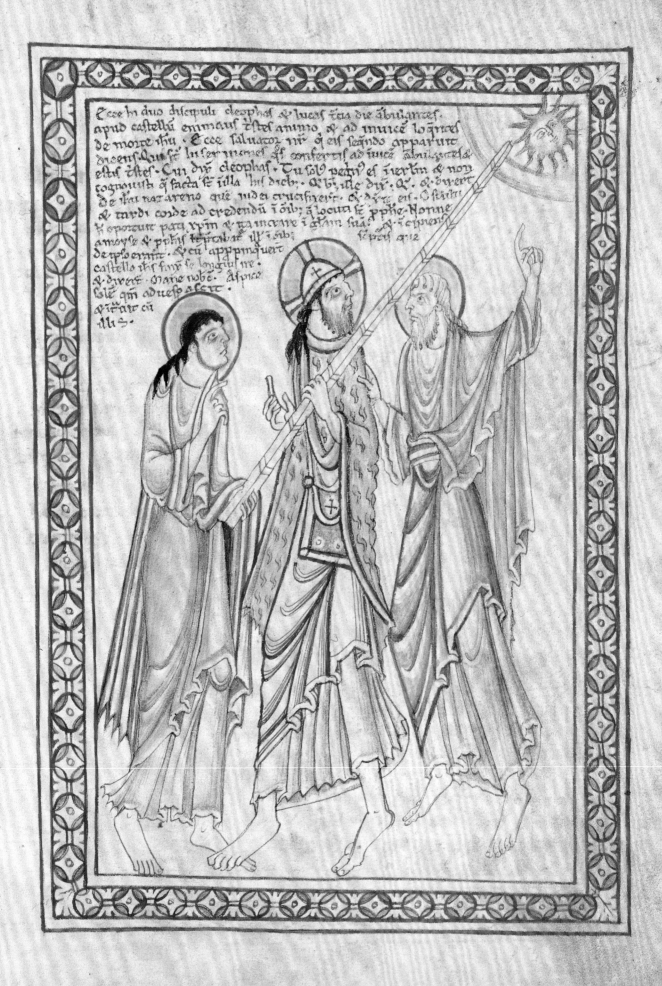

Fig. 27
The Road to Emmaus
St. Albans Psalter, p. 69

Fig. 28
*Christ's Disappearance
from Emmaus*
St. Albans Psalter, p. 71

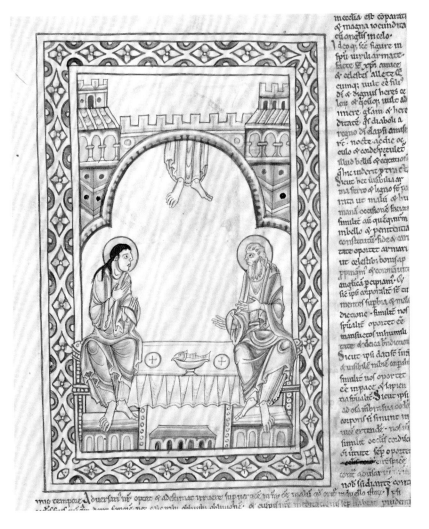

devotional book. The letter from Pope Gregory has been interpreted as a commentary on the book's pictures, either those in this quire or those in the prefatory cycle.[57] The three full-page pictures illustrating Christ's appearance at Emmaus after his Resurrection provide an element of the Passion story not represented in the picture cycle. These are usually attributed to the Alexis Master, the painter of the prefatory cycle, but, in contrast to the prefatory cycle's miniatures, the Emmaus scenes are executed in thinly painted washes.

In the first image, the disciples Cleopas and Luke, on their way to Emmaus, invite an unknown stranger to join them for the evening meal, pointing to the setting sun (fig. 27). Christ carries the staff and satchel commonly seen in medieval images of pilgrims. Above the figures' heads, the scribe has squeezed a shortened version of the account in Luke's Gospel. In the final image of the sequence, Christ vanishes from the disciples' sight, revealing his true nature through this miraculous act (fig. 28). As a way of picturing Christ's sudden, shocking absence, the artist has employed the dangling feet used in earlier Anglo-Saxon images of Christ's ascent to heaven.[58] The text crowded into the right margin of this page

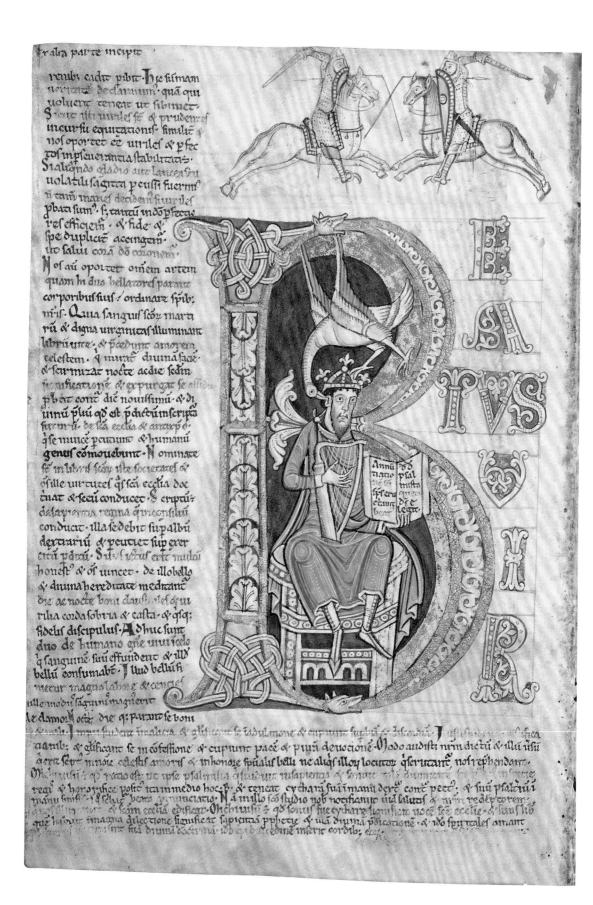

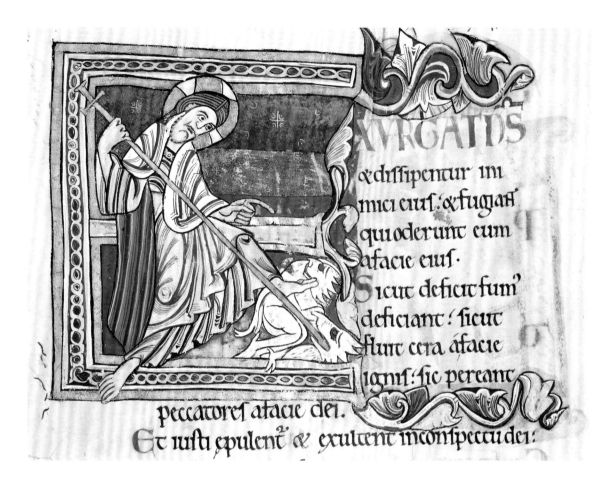

exurgat ds

& diffipentur im
miei eiuf.& fugiat
qui oderunt eum
afacie eiuf.
Sicut deficit fum'
deficiant: sicut
flunt cera afacie
ignif: sic pereant
peccatoref afacie dei.
Et iusti epulent' & exultent inconspectu dei:

Fig. 29
Beatus Initial with Text on
Spiritual Battle
St. Albans Psalter, p. 72

Fig. 30
Psalm 67, Initial *E*
St. Albans Psalter, p. 198

is not devoted to the Emmaus story but instead offers a discourse on spiritual battle. The script continues onto the next page, where two knights on horseback do battle in the space above an initial *B*, which begins the first words of the first psalm: "Beatus vir" (Blessed is the man) (fig. 29). The spiritual battle text and its accompanying images can be seen as an appropriate lead-in for the book of Psalms, for the psalms were perceived as weapons in the daily spiritual battle of the Christian faithful (fig. 30).[59] When the time came to join the Alexis Quire to the rest of the psalter, this page softened the distinction between two separate sections of the manuscript. Gold leaf was added to the edges of the Beatus Initial, and a new bifolium with the opening words of the first psalm written in large display script was added (fig. 31).

Likely commissioned by Geoffrey, the Alexis Quire may initially have been intended for his personal reading or as a teaching tool. While the booklet could have been used for readings in the Alexis Chapel, its use of a vernacular language (French) and the way it addresses the reader as "you" (singular) on the final page could also suggest that the texts were intended for an audience more intimate than groups of dignitaries and pilgrims to St. Albans.[60] Recent arguments have suggested that this quire was intended either as a guide for Christina's personal devotions or as a booklet the abbot could read aloud to her.[61]

Fig. 31
First page of Psalm 1
St. Albans Psalter, p. 73

Supporting this hypothesis, the Alexis miniature (see fig. 26) clearly emphasizes the role of a woman, both in its choice of scenes (marriage rather than the more typical death of a saint) and in its execution. Alexis's wife stands at the center of the composition and is shown in three-quarter view, a compositional device reserved for only the most important figures (the supporting figures are largely shown in profile).[62] While this image has long been interpreted as a deliberate reflection of Christina's biography, it has recently been suggested that Alexis's model of chaste marriage may have evoked thoughts, not of the husband she abandoned, but of her ardent spiritual relationship with Geoffrey.[63]

The quire may have been created, as Morgan Powell and Rodney M. Thomson have suggested, as Abbot Geoffrey's "drawing board" or "worksheet."[64] Without suggesting that the quire was the product of Geoffrey's own hand, these scholars pointed out that the abbot had the resources to personally guide its fabrication. Texts and pictures having particular meaning or utility for him were likely added piecemeal, contributing to the booklet's eclectic nature.

The Psalter | The language of the psalms permeated all aspects of monastic life in the Middle Ages. The psalms formed the core of the monastic office, daily prayers, and ceremonies that structured a monk's life. They were the basis for the Benedictine liturgy of the hours, the ritual foundation of a monk's daily devotions. According to the Rule of Saint Benedict, monks were required to recite the entire psalter each week. Throughout the early and high Middle Ages, the psalter was also the preeminent manual for personal devotion among the laity. Christina of Markyate was said to have sat with her psalter on her lap "reading and singing . . . the psalms day and night."[65] From the psalter, individuals learned to read the Latin words they had already committed to memory through years of recitation, both in church and in the home.[66] In the St. Albans Psalter, 183 historiated initials give visual form to the psalms, some of which received multiple illuminations.

Earlier psalters, such as the Carolingian Utrecht Psalter (ca. 820–35) and one of its English copies, adopted a literal line-by-line approach to illustrating the psalms while still interpreting the prayers from a Christian worldview.[67] Unlike these directly illustrative scenes, the St. Albans initials provide visual, and literal, representations of one or two lines of the psalm and its author. As medieval Christians ascribed the psalms to King David, the psalmist is thus often shown as a regal figure, wearing either a crown or a gold-banded cap (fig. 32). Pictures of Christ and the psalmist appear together repeatedly in the scenes of battle and discourse that accompany the adjacent texts. For Psalm 24, the initial *A* introduces the words "Ad te," the opening of the prayer that commences "To you Lord, I have lifted up my soul" (fig. 33). The psalmist kneels, hands raised in prayer, before Christ, who lifts the tiny figure of the psalmist's soul from his mouth.

Effusa est contemptio sup principes:
& errare fecit eos in inuio & non inuia.
Et adiuuit paupe de inopia:
& posuit sicut oues familias.
Videbunt recti & letabuntur:
& omis iniquitas oppilabit ossuii.
Quis sapiens & custodiet hec:
& intelliget misedias dni.

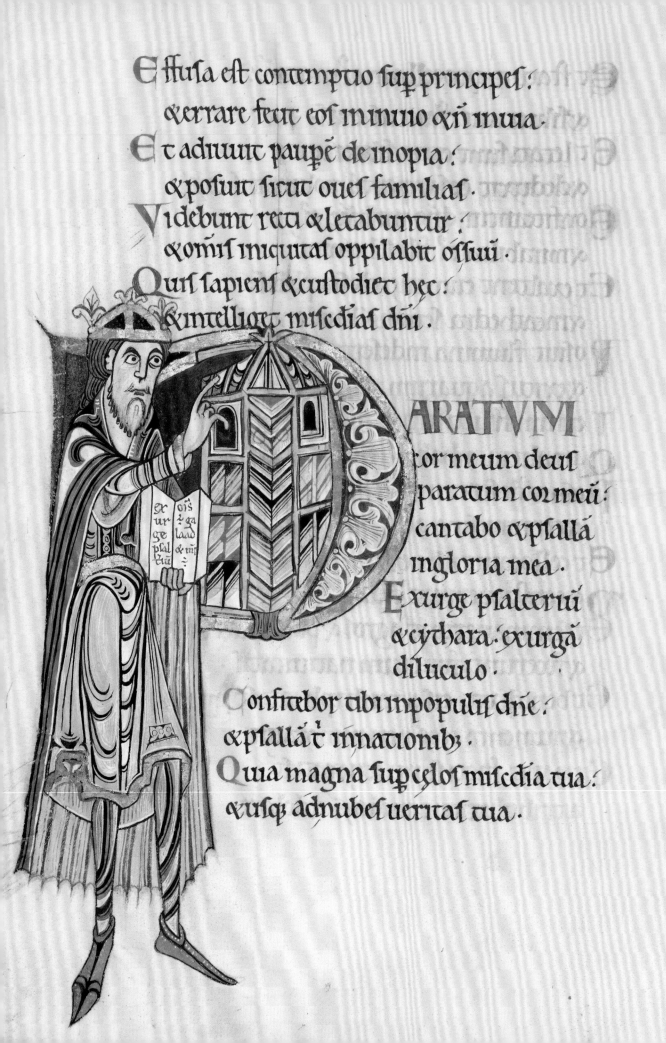

ARATVM
cor meum deus
paratum cor meii:
cantabo & psallá
ingloria mea.
Exurge psalterii
& cythara: exurgã
diluculo.
Confitebor tibi inpopulis dne:
& psallá t innationib;
Quia magna sup celos misedia tua:
& usq; adnubes ueritas tua.

Fig. 32
Psalm 107, Initial *P*
St. Albans Psalter, p. 294

Fig. 33
Psalm 24, Initial *A*
St. Albans Psalter, p. 115

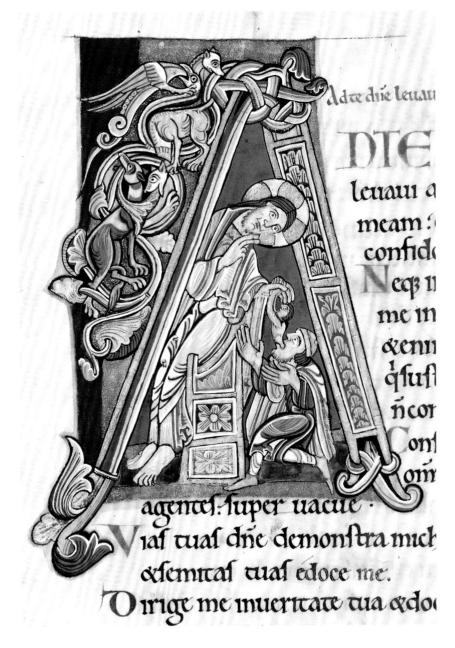

Rubrics are included on the books held by figures within the initials or inserted into available spaces at the start of the psalm text (figs. 34, 35). Added by a hand different from that of the primary scribe of the psalms texts, and after the initials were illuminated, these inscriptions appear to be the work of the same scribe who wrote the Alexis Quire and the obit for Roger the Hermit.[68] They deviate from the standard format for psalter rubrics, which in twelfth-century examples usually provided the psalm number and title.[69] Often the rubric directs the reader to the line of the psalm that is illustrated, but sometimes it repeats a line from the psalm that is not pictured. In the initial for Psalm 21, which begins, "God my God . . . why have you forsaken me," the rubric echoes a line on

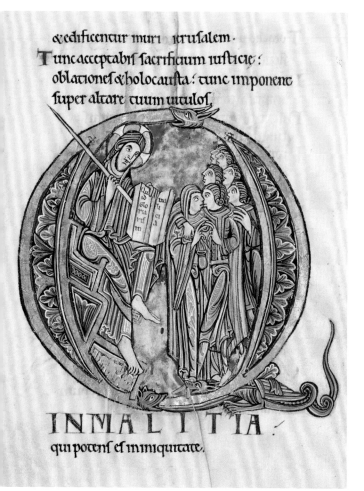

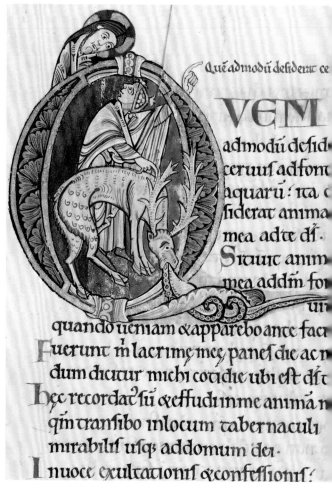

the following page, "calves have surrounded me" (fig. 36). An unclothed figure grasps the edges of the initial *D* as he leaps nimbly over a herd of bovines. Saint Jerome had interpreted calves as symbols of lust and dissipation.[70] The image represents the naked soul energetically resisting these evils with the assistance of God. While the text of the psalm expresses general despair, the artist seems to have seized upon the hope of salvation expressed in the lines "In you have our fathers hoped: / they hoped and you have delivered them."

Throughout the psalter, the artists deftly molded the figures in and around their surrounding letterforms to evoke the spirit of the accompanying prayer, whether utterances of despair, battle cries, or offerings of humble thanks. Psalm 68, beginning "Save me God: because waters are entered even into my soul," shows Christ dragging the psalmist to safety by his hair (fig. 37). The artists have used the curving letterform of the initial *S* and the movement of the teeming fish to direct the movement of water, which seems to pour directly into the figure's open mouth. Similarly, in Psalm 118:71, "It is good that you have humbled me," the psalmist's bended knees conform to the curving shape of the initial *B* that surrounds him (fig. 38).

Fig. 34
Psalm 51, Initial *Q*
St. Albans Psalter, p. 173

Fig. 35
Psalm 41, Initial *Q*
St. Albans Psalter, p. 154

Fig. 36
Psalm 21, Initial *D*
St. Albans Psalter, p. 109

Fig. 37
Psalm 68, Initial *S*
St. Albans Psalter, p. 202

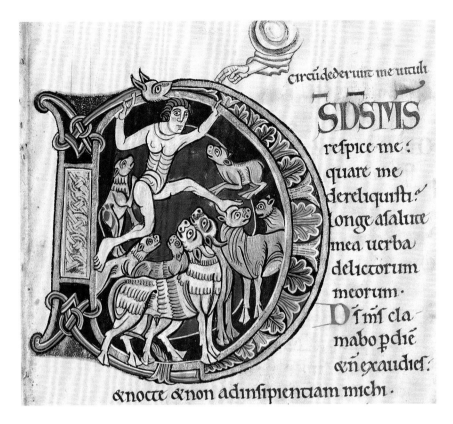

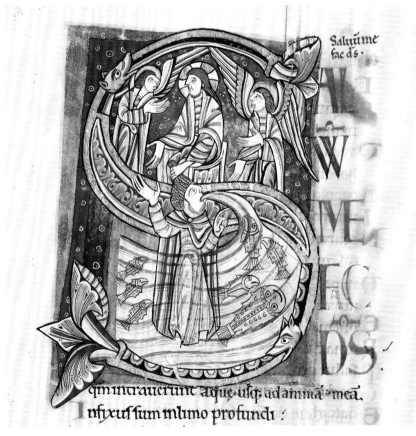

Fig. 38
Psalm 118:71, Initial *B*
St. Albans Psalter, p. 319

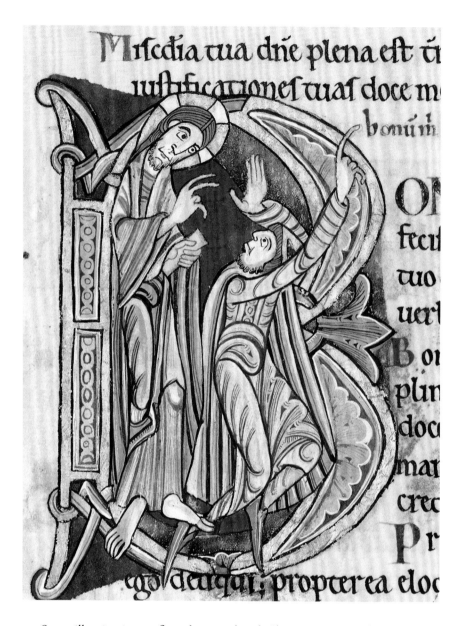

Some illuminations reflect their medieval Christian context through references to church ceremony and religious commentary. The text of Psalm 71, illustrated with an image of the Magi, was read at the offertory of the Mass as the gifts were presented at the altar (fig. 39).[71] Similarly, Psalm 25, "I will wash my hands among the innocent," shows a priest surrounded by tonsured figures washing his hands as a part of the ritual of the Mass (fig. 40).

One of the outstanding questions about the St. Albans Psalter concerns the degree to which its design was geared toward a specific reader. Although the book has long been viewed as Geoffrey's commission, planned to provide guidance for and serving as a reflection of elements of the life of Christina of Markyate, the evidence provided by the interactions among scribes and artists would seem to argue for a much more complicated reading of the book as a tool for directed

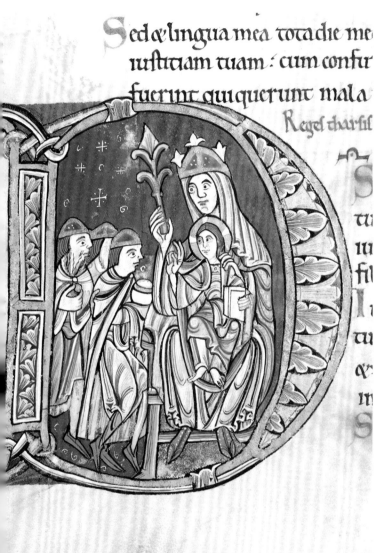

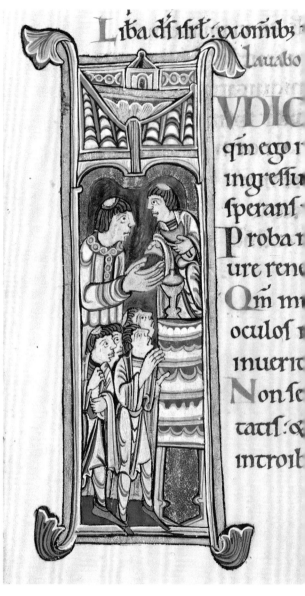

Fig. 39
Psalm 71, Initial *D*
St. Albans Psalter, p. 210

Fig. 40
Psalm 25, Initial *I*
St. Albans Psalter, p. 117

reading. The underdrawings for the illuminations of the initials were executed by the Calendar Artist, who created the tinted drawings in the calendar section, but they were fully painted by at least two other illuminators.[72] Any given page may contain the work of as many as four or five craftsmen: the primary scribe, the draftsman who designed the initial, the illuminator or illuminators who painted it, and finally the rubricator. With so many individuals jockeying for the limited space on the page, it is perhaps not surprising that the illumination frequently encroaches upon, or overlaps, the surrounding text, or that the rubrics, added last, are occasionally crammed into narrow spaces between lines of text.

A puzzling aspect of the interaction of picture and text is that the rubrics do not adhere to a single system. As noted above, most echo the first line of the psalm, while others call out a line of text that has not been illustrated. These

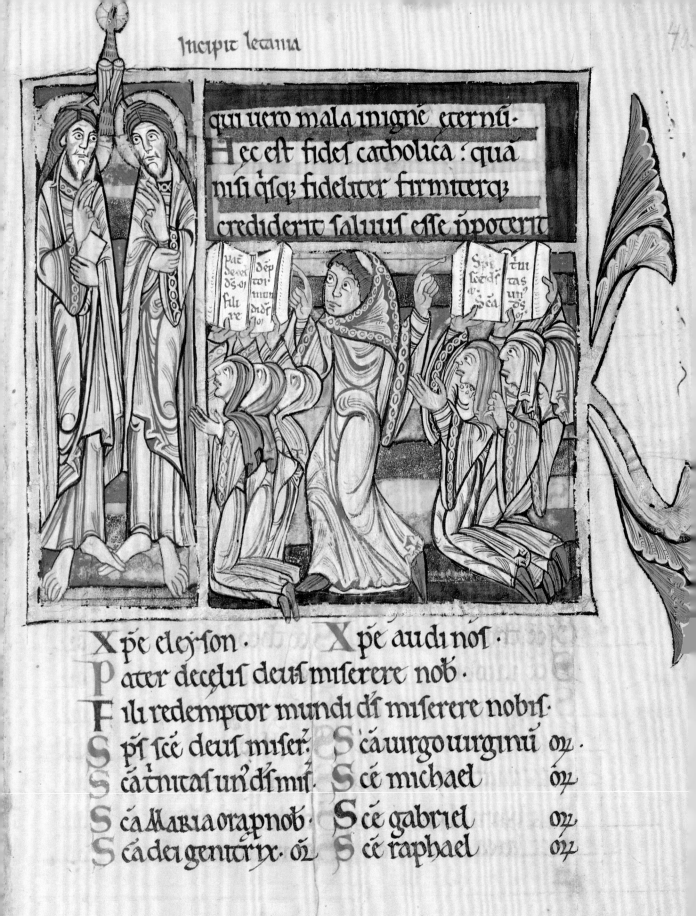

qui uero mala inigne eternu.
Hec est fides catholica : qua
nisi qsq; fideliter firmiterq;
crediderit saluus esse ipoterit

Xpe eleyson . Xpe audi nos .
Pater decelis deus miserere nob .
Fili redemptor mundi ds miserere nobis .
Spr sce deus miser: Sca urgo urginu oz .
ca trnitas un ds mis. Sce michael oz
ca Maria orapnob . Sce gabriel oz
ca dei genitrix . oz Sce raphael oz

artistic and scribal deviations and repetitions ultimately call into question the degree to which the pictures and texts were intended to be read as a cohesive process. It has been suggested that the rubrics' odd repetition of the first line of text could indicate that the initials were being set apart as devotional aids.[73] Despite the fact that the initials are literally embedded in the accompanying text, they may have functioned much as the pictures in the prefatory cycle did: as objects of contemplation, meant to spark remembered passages of the psalms the reader had long since committed to memory.

Following the psalms are the litany, canticles, creeds, and collects, prayers commonly found in medieval psalters. The litany was a series of petitions for deliverance or intercession, addressed to apostles, martyrs, confessors, and virgins. The large number of women in the St. Albans Psalter's litany has long been pointed to as evidence for female readership; however, this issue requires further investigation. It is unclear how disproportionately female this litany is when compared with those found in unillustrated monastic psalters from the period.

The litany begins with a large initial *K* in which a group of nuns and one monk kneel before the Trinity, represented as two standing figures and a dove (fig. 41). The picture has been interpreted as a direct reflection of an event recorded in Christina's *vita* and as an image of Christina herself.[74] According to her *vita*, Christina had experienced a vision in which she stood in the presence of two figures, clothed in white and with a dove at rest on their shoulders. In her vision she interceded with the divinity on behalf of Geoffrey, who stood just outside the door to the room in which she stood. The specific details of this story could explain why the dove's wings, originally drawn outstretched in flight, were erased and changed by the illuminator to be shown closed, as in the *vita*'s account of this event.[75] Whether this picture was intended for Christina or was a means of enshrining her holiness cannot be known. What has long been acknowledged is that the picture in some way reflects the role of women in the spiritual life of St. Albans.

The Diptych | The manuscript concludes with a pictorial diptych showing, at left, the martyrdom of the monastery's name-saint, Alban, and, at right, King David surrounded by musicians (figs. 42, 43). Its full-page miniatures are the work of the Calendar Artist, who was responsible for the calendar and the underdrawings for the psalm initials. Until very recently, the diptych was assumed by most scholars to have been intended as the preface to the psalter. It has been generally thought that at some point, when the Alexis Master began work on the extended picture cycle that now precedes the psalms, the diptych was moved to the back of the volume. In fact, close study of the manuscript has revealed that this diptych is of a piece with the quire that precedes it.[76] Thus it is likely that the diptych is placed where it was always intended to be. The name-saint for the abbey and the supposed author of the psalms provide a fitting close and "defining coda" to this luxurious manuscript.[77]

Fig. 41
Litany, Initial *K*
St. Albans Psalter, p. 403

Following pages
Fig. 42
The Martyrdom of Saint Alban
St. Albans Psalter, p. 416

Fig. 43
King David and His Musicians
St. Albans Psalter, p. 417

51

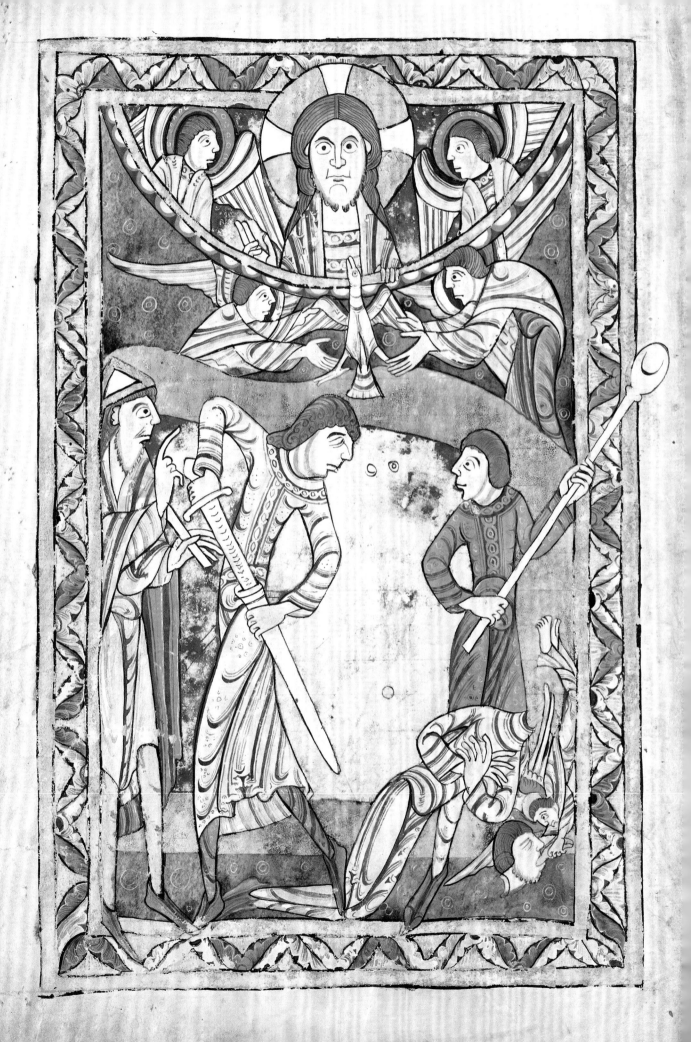

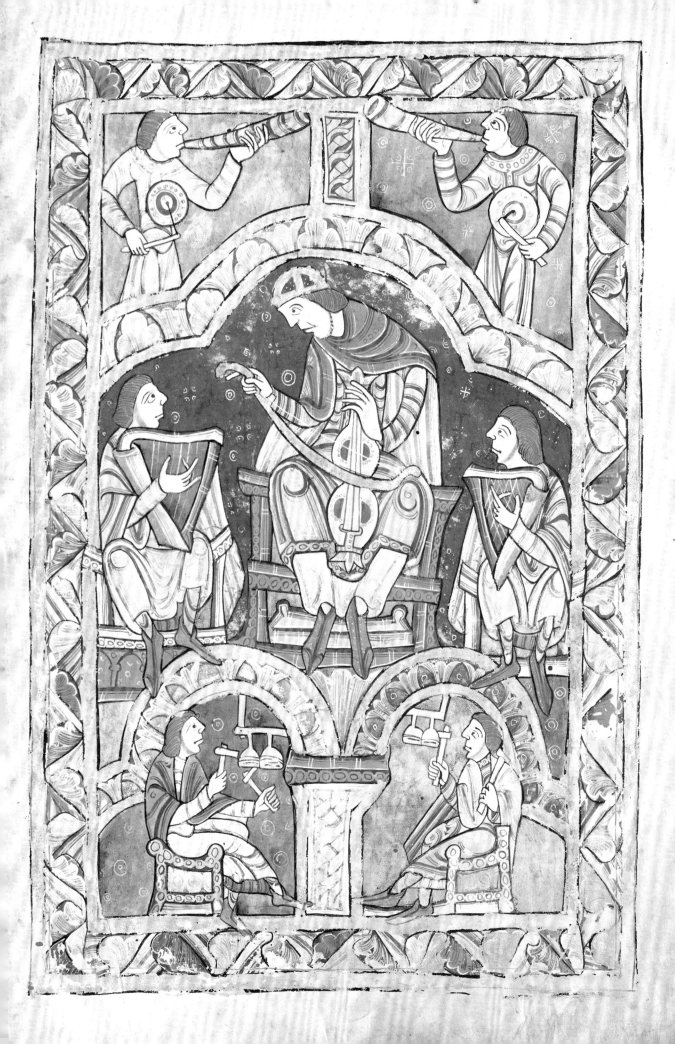

Reading and Responding to Pictures in the St. Albans Psalter

The St. Albans Psalter heralds the twelfth-century expansion of narrative pro-
grams in manuscripts and marks the changing approach to prayer that is else-
where expressed in monastic treatises; narrative became a tool and entry point
into a devotional process. Because the choice of images in twelfth-century pref-
atory cycles was for the most part not dictated by an established text, the pic-
ture cycles provided the reader-viewer with a flexible devotional apparatus. They
demonstrate the degree to which the affective visualization of the life of Christ,
so often associated with late-medieval prayer, is actually found in the visual arts
of the twelfth century.

The letter of Pope Gregory the Great defending the use of images as essentially
Bibles for the "illiterati" was written to Serenus of Marseille in the sixth century,
when Christianity was still becoming established in Gaul. The viewers Gregory
had in mind included groups as disparate as peasants, pagans, and possibly Jews.
"Illiterati" was here a blanket term describing those who could not read and also
those outsiders who were not inclined to access the written (Christian) word of
God. The inclusion of Gregory's letter in the St. Albans Psalter assumes a differ-
ent sort of audience for its pictures; by the twelfth century this text was increas-
ingly aimed toward the lay community, one that encompassed varying degrees
of literacy.[78] In between the literate and illiterate was a middle area, occupied by
those who depended on the assistance of others to access written information.[79]
Thus, individuals who had memorized the psalms but relied on the reading skills
of a clerical adviser could occupy this category.

For these people, pictures served as mnemonic devices and devotional aids.
They could help the reader-viewer recall religious texts that had been commit-
ted to memory. They could also provide a focus for those who might otherwise
lack the discipline for prayer. Monastic treatises attest to the belief that pictures
were acceptable tools for women and novices, who, being rooted in the body,
required the assistance provided by physical images to achieve the goal of spiri-
tual visualization.[80] For example, in the eleventh century, the Benedictine monk
Goscelin's *Liber confortatorius* (Book of consolation) urged the anchoress Eve to
use the sufferings of Christ as a focal point for her meditations.[81] In addition to
providing a focus for meditation, picture cycles in psalters served as a catalyst
to audible prayer. A later-twelfth-century psalter in Oxford contains prayers on
the pages facing the images in the prefatory cycle, while captions were added
above the images themselves.[82] This unusual element suggests something about
the devotional process attached to twelfth-century picture cycles: while the pic-
tures were clearly meant to spark a visual meditative process, they were also
meant to promote active and audible prayer. In the high Middle Ages, when it
was the custom to read aloud, the act of reading was as much about speaking
and hearing as it was about looking.[83] *Libri ordinarii* (Descriptions of liturgical
celebration) from this period attest to the practice; the physical act and memory

Fig. 44
Psalm 43, Initial *D*
St. Albans Psalter, p. 157

Fig. 45
Psalm 44, Initial *E*
St. Albans Psalter, p. 160

of speaking the words formed the basis for *meditatio*.[84] Two of the St. Albans Psalter's images powerfully illustrate this intermingling of the read and spoken words. In Psalm 43, the lines "God we have heard with our ears" are illustrated with a figure who points with one hand to his ear and with the other to the lines of text (fig. 44). In Psalm 44, the rubricator has echoed the words "My tongue is the pen of the scribe who writes swiftly" (fig. 45). The figure in the initial holds a pen aloft in one hand and points with the other to his outstretched tongue.[85]

While early studies of the St. Albans Psalter attributed its evocative and powerful images to the genius of its artists, it can be seen much in a broader cultural context.[86] In the late eleventh and early twelfth centuries, an increased emphasis on Christ's suffering provided individuals with an emotional connection to their spirituality. This trend toward affective piety is seen most powerfully in the writings of Anselm, the archbishop of Canterbury, whose collections of prayers were sent to Adelaide, the daughter of William the Conquerer and the Countess Mathilda of Tuscany. In a letter to Mathilda, Anselm explained that the prayers "are arranged so that by reading them the mind may be stirred up either to the love or fear of God, or to a consideration of both, so they should not be read cursorily or quickly, but little by little, with attention and deep meditation."[87]

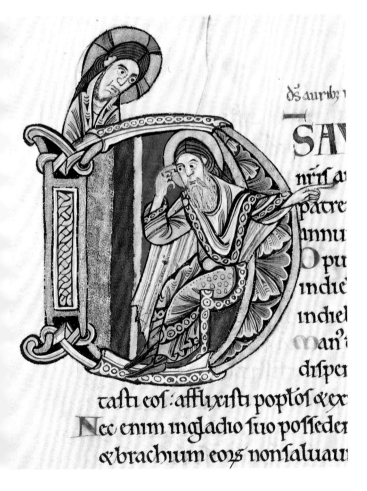

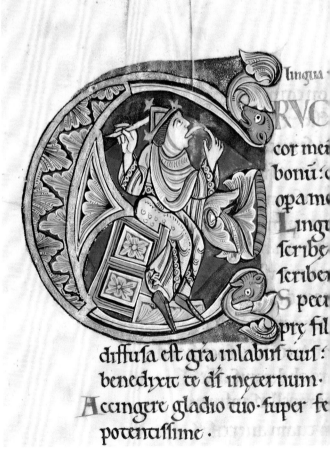

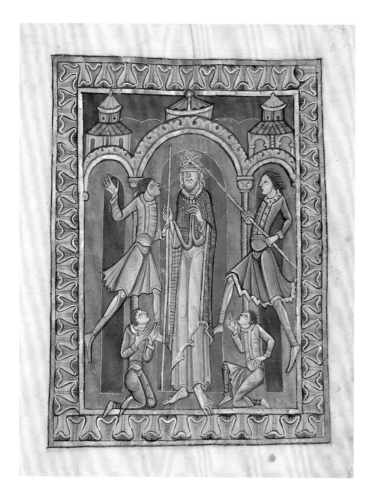

Fig. 46
The Mocking of Christ
St. Albans Psalter, p. 43

Fig. 47
The Mocking of Christ
(detail showing puncture
mark above pupil)
St. Albans Psalter, p. 43

Fig. 48
The Harrowing of Hell
St. Albans Psalter, p. 49

 The St. Albans Psalter contains tangible evidence of an emphatic response to its images in the form of deliberate damage. At some point in its history, a reader engaged in selective acts of iconoclasm, physically damaging demons and tormentors of Christ.[88] An example can be seen in *The Mocking of Christ* (fig. 46), where four tiny puncture marks, no larger than pinpricks, pierce the eyes of the tormentors (fig. 47).[89] This kind of targeted damage is often seen in psalters, although it usually manifests as broad swaths of rubbed pigment, as in the central demon in the St. Albans image *The Harrowing of Hell* (fig. 48).[90] This damage is seen as well in a saint's *vita* illuminated by an artist in the circle of the Alexis Master, where the faces of the tormentors in *The Scourging of Edmund* have been violently scratched (fig. 49).[91]

 The damage to the demons and tormentors of Christ in the St. Albans Psalter is, for the most part, distinguished by its careful restriction to the area of the eyes, leaving the aesthetic beauty of the pages otherwise untouched. In the Middle Ages, it was believed that sight was a process in which rays emanating from the eye rebounded off the perceived object and returned to the eye. The extromission theory of vision meant that to be seen by someone or something evil was a potentially dangerous act. This danger is emphasized in a picture made at

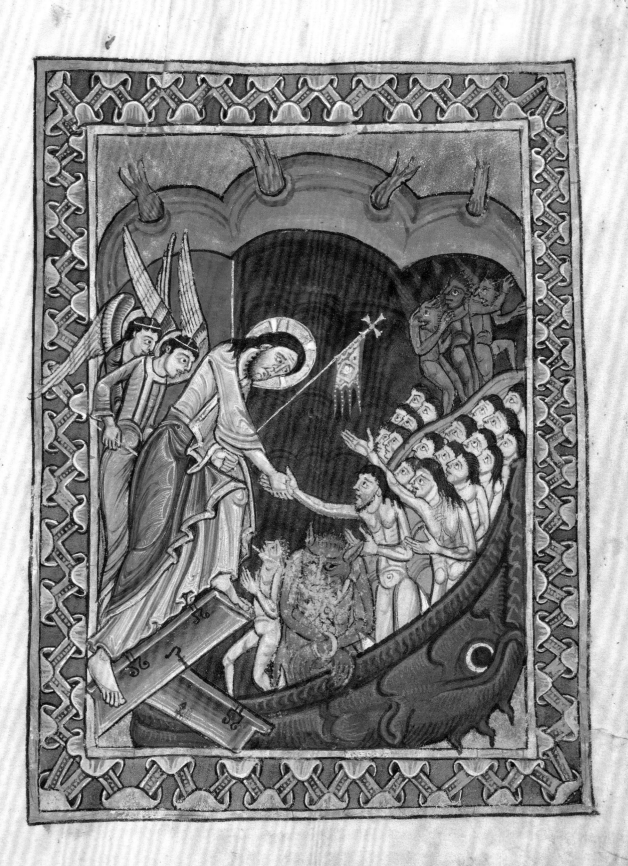

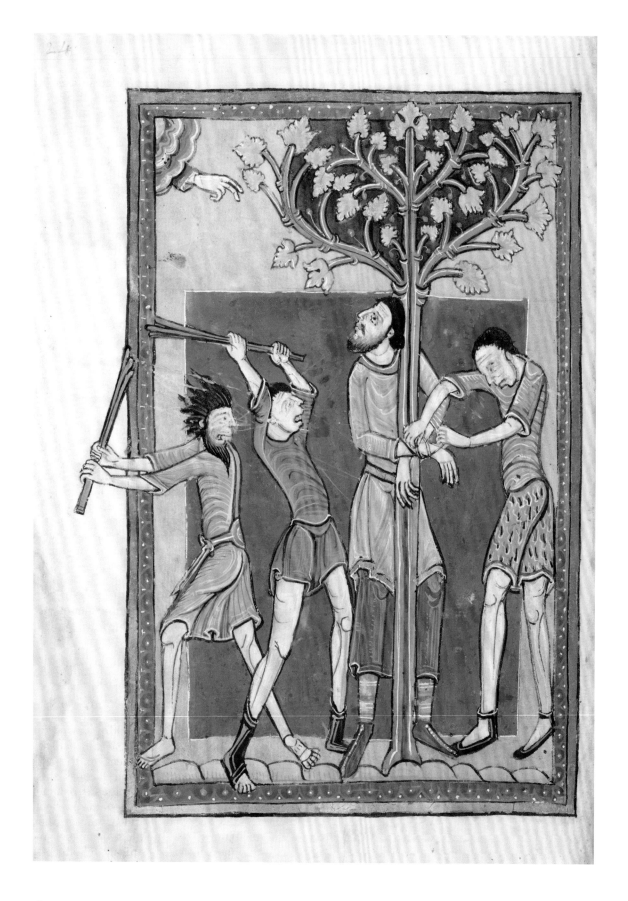

St. Albans, *Faith Killing Idolatry*, in which Idolatry is dispatched by a spear through the eye (see fig. 6).[92] King Harold's reported cause of death by an arrow through the eye at the Battle of Hastings may have represented a similar tradition of symbolic disempowerment.[93] The arrow was not mentioned in the earliest account of the battle, but within thirty years it had been recorded in *The History of the Norman People*.[94] In a similar fashion, one of the St. Albans Psalter's readers was clearly moved to neutralize the supernatural properties of the malignant figures pictured within its pages. While it would be tempting to ascribe this damage to a twelfth-century reader (Christina of Markyate was known for her skilled needlework), it is not possible to know when this damage occurred. What this act of devotional iconoclasm does demonstrate, however, is the pervasive and persistent power that images held for their medieval viewers.

Conclusion

Understanding of the St. Albans Psalter has been shaped by artistic survivals. This manuscript is often touted as a "first"—the vehicle by which the Romanesque style of illumination reached England—and yet the dating of the manuscript remains an open question. The small number of securely dated English manuscripts from this period means that the issue of chronology still remains very much in flux. Recent study of the psalter under the microscope suggests that there is valuable information yet to be gained by a closer comparison of its painting technique and materials with those of closely contemporaneous manuscripts, such as *The Life and Miracles of Saint Edmund* and the Shaftesbury Psalter, which are often mentioned in relation to it.[95] A broader exploration of artistic production at St. Albans, Bury St. Edmunds, Canterbury, and other key areas of manuscript illumination during the period may yield clearer insight into the St. Albans Psalter.

Study of the manuscript has also come to be defined by Christina of Markyate, the woman who may have owned it. The degree to which its imagery was geared toward her readership remains another open question, one that is complicated by evidence of adjustments to the manuscript's original plan during production. In the absence of definitive answers, it is perhaps useful to consider the manuscript in its broader cultural context. Just as the medium of sculpture came to represent the idea of Romanesque in France and Spain, it was in the medium of manuscript illumination that English Romanesque art reached new heights in the twelfth century. The St. Albans Psalter reveals a moment when pictures in books became an integral part of the devotional process—captivating the eye, conveying narrative on an unprecedented scale, and condensing the complex poetry of the psalms into pictorial form.

Fig. 49

The Scourging of Edmund
The Life and Miracles of Saint Edmund
Bury St. Edmunds, England, first half of the 12th century
New York, Morgan Library & Museum, Ms. M.736, fol. 13v

Notes

1. The numbering of the psalms varies among different translations of the Bible. The numbering familiar to most Protestants is derived from the Hebrew Bible. (The King James Version provides such an example.) Catholic translations such as the Douay-Rheims Version (used as a standard in this publication) adhere most closely to the numbering used by medieval psalters such as the St. Albans Psalter. In this essay, translations from the psalms and other materials in the psalter are those provided by Susan Niebrzdowski for the University of Aberdeen St Albans Psalter website, accessed December 12, 2012, http://www.abdn.ac.uk/stalbanspsalter/. Quotations from the New Testament are from the Douay-Rheims Version.

2. For a description of the St. Albans Psalter, see Appendix 1. For help with understanding the specialized terminology of medieval monastic life and manuscripts, see the glossary in Appendix 2.

3. *Gesta Abbatum Monasterii Sancti Albani a Thoma Walsingham*, edited by Henry Thomas Riley (London, 1867), vol. 1, pp. 29a–39a.

4. Rodney M. Thomson, *Manuscripts from St Albans Abbey, 1066–1235* (Woodbridge, Suffolk, 1982), p. 13.

5. See, for example, London, British Library, Cotton Ms. Titus D.xvi.

6. See the essay by Kidd and Turner in this volume.

7. Donald Matthew, "The Incongruities of the St Albans Psalter," *Journal of Medieval History* 34 (2008), pp. 396–416, especially p. 415; Patricia Stirnemann, "The St Albans Psalter: One Man's Spiritual Journey," in *Der Albani-Psalter: Stand und Perspektiven der Forschung / The St Albans Psalter: Current Research and Perspectives*, edited by Jochen Bepler and Christian Heitzmann (Hildesheim, forthcoming). The crucial issue of dating this manuscript is problematic and remains a matter of ongoing study. Until 1960, the book was thought to have been created during the years of Abbot Geoffrey's rule, about 1119–46. In 1960, the date 1123 was proposed, based on the obit for Roger the Hermit, who died in 1121 or 1122 and whose death date would presumably, the argument goes, have been entered into the calendar soon thereafter. C. R. Dodwell, "Note on the Date of the St. Albans Psalter," in Otto Pächt, C. R. Dodwell, and Francis Wormald, *The St. Albans Psalter (Albani Psalter)* (London, 1960), pp. 278–80. In 1982 this date was questioned, and it was broadened to 1120–30 on the basis of script and codicology. Thomson, *Manuscripts from St Albans*, p. 25. More recently Rodney M. Thomson has suggested that the book could not have been made before 1129. Rodney M. Thomson, "The St Albans Psalter: Abbot Geoffrey's Book?" in *Der Albani-Psalter*, ed. Bepler and Heitzmann, forthcoming. The biography of Christina (to be discussed further in this essay) has been used to propose dates as divergent as pre-1121 and post-1146.

8. Cambridge, Corpus Christi College, Ms. 2; C. M. Kauffmann, *Romanesque Manuscripts, 1066–1190*, A Survey of Manuscripts Illuminated in the British Isles, vol. 3 (London, 1975), no. 56; Paul Binski and Stella Panayotova, eds., *The Cambridge Illuminations: Ten Centuries of Book Production in the Medieval West*, exh. cat. (Cambridge: Fitzwilliam Museum, 2005), no. 19; Rodney M. Thomson, *The Bury Bible* (Rochester, N.Y., 2001).

9. Adolph Goldschmidt, *Der Albanipsalter in Hildesheim und seine Beziehung zur symbolischen Kirchensculptur des XII. Jahrhunderts* (Berlin, 1895); Pächt, Dodwell, and Wormald, *St. Albans Psalter.*

10. Michael Camille, "Seeing and Reading: Some Implications of Medieval Literacy and Illiteracy," *Art History* 8, no. 1 (March 1985), pp. 26–49; Ursula Nilgen, "Psalter der Christina von Markyate (sogenannter Albani-Psalter)," in *Der Schatz von St Godehard*, exh. cat. (Hildesheim: Diözesan-Museum Hildesheim, 1995), no. 69, pp. 152–65; Madeline H. Caviness, "Anchoress, Abbess, Queen: Donors and Patrons or Intercessors and Matrons?," in *The Cultural Patronage of Medieval Women*, edited by J. H. McCash (Athens, Ga., 1996), pp. 105–53; Magdalena Elizabeth Carrasco, "The Imagery of the Magdalen in Christina of Markyate's Psalter (The St Albans Psalter)," *Gesta* 37 (1999), pp. 67–80; Jane Geddes, *The St Albans Psalter: A Book for Christina of Markyate* (London, 2005); Ursula Nilgen, "Psalter für Gelehrte und Ungelehrte im hohen Mittelalter," in *The Illuminated Psalter: Studies in the Content, Purpose and Placement of Its Images*, edited by F. O. Büttner (Turnhout, Belgium, 2004), pp. 239–47, ills. 220–27.

11. *The Life of Christina of Markyate: A Twelfth Century Recluse*, edited and translated by C. H. Talbot, Oxford Medieval Texts (Oxford, 1959; revised and reprinted 1987, 1997, 1998); *Vie de Christina de Markyate*, edited and translated by Paulette L'Hermite-Leclercq and Anne-Marie Legras, Sources d'Histoire Médiévale, publiées par l'Institut de Recherche et d'Histoire des Textes 35 (Paris, 2007). See also Samuel Fanous and Henrietta Leyser, eds., *Christina of Markyate: A Twelfth-Century Holy Woman* (London, 2005); Rachel M. Koopmans, "The Conclusion of Christina of Markyate's *Vita*," *Journal of Ecclesiastical History* 51 (October 2000), pp. 663–98; Nancy Partner, "Christina of Markyate and Theodora of Huntingdon: Narrative Careers," in *Reading Medieval Culture: Essays in Honor of Robert W. Hanning*, edited by Robert M. Stein and Sandra Pierson Prior (Notre Dame, Ind., 2005), pp. 111–31.

12. While Talbot (*Life of Christina*, p. 15) thought that the two likely met as early as 1124, L'Hermite-Leclercq (*Vie de Christina*, vol. 2, p. 39) has more recently suggested that they became acquainted at the beginning of the 1130s.

13. The eleventh century provides numerous examples of this model: Goscelin and the nun Eve of Wilton, Anselm and

Adelaide, Peter Damian and Agnes of Poitou. Sarah McNamer, *Affective Meditation and the Invention of Medieval Compassion* (Philadelphia, 2009).

14. Talbot, *Life of Christina*, p. 161.

15. For more on the relationship of hermits with their surrounding communities, see Henry Mayr-Harting, "The Functions of a Twelfth-Century Recluse," *History* 60 (1975), pp. 337–52; Christopher Holdsworth, "Christina of Markyate," in *Medieval Women*, edited by Derek Baker (Oxford, 1978), pp. 185–204.

16. Peter Kidd, "Contents and Codicology," in *The St Albans Psalter (Albani Psalter)*, facsimile edition, commentary by Jochen Bepler, Peter Kidd, and Jane Geddes (Simbach am Inn, Germany, 2008), pp. 104–6. See note 1 above for a discussion of the numbering of the psalms and their translations.

17. For interpretation of the initial as commemorative element, see Larry Ayres, "The Role of an Angevin Style in English Romanesque Painting," *Zeitschrift für Kunstgeschichte* 37 (1974), pp. 214–15. The year of Christina's death is not known. The last mention of her is found in a pipe roll entry of 1155, when she received 50 shillings a year as support from King Henry II. *The Great Rolls of the Pipe for the Second, Third, and Fourth Years of the Reign of Henry II*, edited by Joseph Hunter (London, 1844), p. 22.

18. The stamp of Christina is so firmly imprinted on the scholarship that she is at times even referred to as the book's "patron." See, for example, Robert Deshman, "Another Look at the Disappearing Christ: Corporeal and Spiritual Vision in Early Medieval Images," *Art Bulletin* 89 (1997), p. 544; Michael Camille, "Philological Iconoclasm: Edition and Image in the *Vie de Saint Alexis*," in *Medievalism and the Modernist Temper*, edited by R. Howard Bloch and Stephen G. Nichols (Baltimore, 1996), p. 372.

19. Caviness, "Anchoress, Abbess, Queen," pp. 112–13.

20. Carrasco, "Imagery of the Magdalen," pp. 67–68.

21. Thomson, "St Albans Psalter." The suggestion that the book was too expensive for an anchoress raises the question of how costly this manuscript really was for its time. For a closer examination of the material aspects the St. Albans Psalter, see the essay by Kidd and Turner in this volume.

22. Thomson, "St Albans Psalter." For a problematization of Christina's literacy, see Morgan Powell, "The Visual, the Visionary and Her Viewer: Media and Presence in the Psalter of Christina of Markyate (St. Albans Psalter)," *Word and Image* 22 (October–December 2006), pp. 340–62, specifically pp. 347–49.

23. Since 1960, scholars such as Francis Wormald (in *The St. Albans Psalter*), and more recently Donald Matthew ("Incongruities of the St Albans Psalter") have pointed out that the calendar, which is widely recognized as expressing a personal rather than an institutional aspect, reflects an interest in saints particularly venerated at Ramsey Abbey, located in the area near Huntingdon where Christina was raised.

24. James Carson Webster, *The Labors of the Months in Antique and Medieval Art to the End of the Twelfth Century* (New York, 1970), pp. 93–94.

25. Kidd, "Contents and Codicology," pp. 131–32; see also the essay by Kidd and Turner in this volume.

26. The lack of adherence to a "standard program" needs to be qualified by the small group of surviving examples: only two full and one partial St. Albans calendars remain from this period. Francis Wormald, *English Benedictine Kalendars after A.D. 1100* (Woodbridge, Suffolk, 1939), vol. 1, pp. 31–45. Peter Kidd notes that the feast of the invention of Saint Alban is not found in extant Anglo-Saxon calendars and suggests further that in post-Conquest examples the feast is perhaps a feature only of calendars from St. Albans and its dependencies. Kidd, "Contents and Codicology," p. 64.

27. The inscription could refer to the richly illuminated psalter with which the calendar is now bound or to an older manuscript with which the calendar was initially paired. Morgan Powell, "Making the Psalter of Christina of Markyate (The St. Albans Psalter)," *Viator* 36 (2005), pp. 293–335.

28. Ernst Guldan, *Eva und Maria: Ein Antithese als Bildmotiv* (Graz, Austria, 1966), pp. 13–20.

29. Powell, "The Visual, the Visionary," pp. 355–56.

30. The roughly contemporaneous Melisende Psalter (London, British Library, Egerton Ms. 1139), painted by Frankish artists in Jerusalem between 1131 and 1143, contains a prefatory cycle of twenty-four full-page miniatures of the life of Christ. This, in addition to an early-twelfth-century description of two now-lost manuscripts, thought to be northern French and containing extensive prefatory cycles, may attest to a tradition in France. Francis Wormald, "A Medieval Description of Two Medieval Psalters," *Scriptorium: International Review of Manuscript Studies* 6 (1952), pp. 18–25.

31. London, British Library, Cotton Ms. Tiberius C.vi.

32. Camille, "Seeing and Reading," pp. 27–28.

33. Kathryn Horst, "The Passion Series from La Daurade and Problems of Narrative Composition in the Cloister Capital," *Gesta* 21 (1982), pp. 31–62, especially p. 49, figs. 17a–b.

34. Otto Pächt, "The Full-Page Miniatures," in Pächt, Dodwell, and Wormald, *St. Albans Psalter*, p. 89; Geddes, *St Albans Psalter*, p. 20.

35. The cloister capital from La Daurade is in the Musée des Augustins, Toulouse. See Horst, "Passion Series," p. 49.

36. The cloister capital from Pamplona is in the Museo de Navarra, Pamplona. Pächt ("Full-Page Miniatures," p. 62) says this scene is known in Western art by two earlier isolated examples: the casket of Paschal I (817–824) (Biblioteca Apostolica Vaticana, Museo Sacro, Inv. 985) and the Uta Codex (ca. 1025) (Munich, Bayerische Staatsbibliothek, Clm 13601, fol. 41).

37. Itinerant artists were known to have ranged widely in the twelfth century, traveling between England and the Continent. Walter Oakeshott, *Sigena: Romanesque Paintings in Spain and the Winchester Bible Artists* (London, 1972).

38. Caviness, "Anchoress, Abbess, Queen," pp. 112–13.

39. Carrasco, "Imagery of the Magdalen," pp. 75–76.

40. Geddes, *St Albans Psalter*, p. 20; Felix Heinzer, "'Wondrous Machine': Rollen und Funktionen des Psalters in der mittelalterlichen Kultur," in *Der Albani-Psalter*, ed. Bepler and Heitzmann, forthcoming.

41. Elizabeth Parker, "The Descent from the Cross: Its Relation to the Extra-Liturgical 'Depositio' Drama" (PhD diss., New York University, 1975), pp. 10–11. Linda Seidel discusses *The Harrowing of Hell* as one such substitution image in cloister sculpture. Linda Seidel, "Medieval Cloister Carving and Monastic Mentalité," in *The Medieval Monastery*, edited by Andrew MacLeish (St. Cloud, Minn., 1988), pp. 3–4.

42. For a discussion of the new affectivity present in eleventh-century devotional texts, see Rachel Fulton, *From Judgment to Passion: Devotion to Christ and the Virgin Mary, 800–1200* (New York, 2002), especially "Praying to the Crucified Christ," pp. 143–92. McNamer, *Affective Meditation*, pp. 68–69, outlines the beginning of the tradition.

43. Peter Damian, *The Letters of Peter Damian*. Trans. Owen J. Blum. (Washington D.C., 1989–1998), vol. 3, pp. 46–47.

44. Peter Damian, *Opuscula* 19.5, in *Patrologia Latina*, vol. 145, col. 432.

45. Fulton, *From Judgment to Passion*, pp. 143–92.

46. The changing expectations for the construction of linear narrative in manuscripts likely relate to the evolution of pure picture cycles from the context of liturgical books (in which pictures were ordered or included to illustrate important feast days) to the sphere of personal devotion.

47. Richter of Metz, *Vita Sancti Martini*, after 1102, Trier, Stadtbibliothek, Cod. 1378/103, fol. 132v; Martin de Tours, *Du Légionaire au saint évêque*, edited by Jean-Pierre Delville, Marylène Laffineur-Crépin, and Albert Lemeunier (Liège, 1994), pp. 70–71; G. Franz, *Trierer und Echternacher Handschriften*, Ausstellungskataloge Trier Bibliotheken 13 (Trier, 1987), pp. 40–44. Renate Kroos, "Sammelband mit Vita sancti Martini," in *Die Zeit der Staufer, Geschichte, Kunst, Kulture: Katalog der Ausstellung*, edited by Reiner Haussherr (Stuttgart, 1977), no. 750, pp. 578–80. I thank Peter Kidd for bringing my attention to this example.

48. Geddes, *St Albans Psalter*, p. 61.

49. Carrasco, "Imagery of the Magdalen," p. 70.

50. Jane Geddes found that there is a contemporary church dedicated to Saint Martin in Gorron. Conversation noted by Thomson in "St Albans Psalter." Peter Kidd subsequently found the following documentation dating the dedication to 1082. I would like to thank him for sharing this citation with me. "La Paroisse de Gorron des origins a 1780: Notes et Documents, Chapitre Ier. L'ancienne eglise," *Bulletin de la Commission Historique et Archeologique de la Mayenne*, Crée par arrêté préfectoral du 17 Janvier 1878, Deuxième Série Tome Trente-Troisième, 1917 (Laval, 1917), pp. 34–35.

51. *Gesta Abbatum*, ed. Riley, vol. 1, pp. 95–96.

52. Powell, "Making the Psalter," pp. 293–335; Kathryn B. Gerry, "The Alexis Quire and the Cult of Saints at St. Albans," *Historical Research* 82 (2009), pp. 593–612; Kathryn Gerry, "The Alexis Quire in the St. Albans Psalter and the Monastic Community of St. Albans" (PhD diss., Johns Hopkins University, 2007). Gerry argues that the quire might have been a separate, unbound booklet before being sewn into the larger manuscript, but recent examination of the sewing structure suggests that the book was planned as a cohesive entity.

53. *The Life of St. Alexis in the Old French Version of the Hildesheim Manuscript*, edited by Carl J. Odenkirchen (Brookline, Mass., 1978); Tony Hunt, "The Life of St. Alexis, 475–1125," in *Christina of Markyate*, ed. Fanous and Leyser, pp. 217–28.

54. Pächt, "Full-Page Miniatures," p. 136; Talbot, *Life of Christina*, p. 26.

55. Gerry, "Alexis Quire in the St. Albans Psalter"; Gerry, "Alexis Quire and the Cult of Saints," pp. 606–11. Gerry discusses the monastic tradition of unillustrated quartos containing hagiographic material. For more on illustrated saints' lives, see Francis Wormald, "Some Illustrated Manuscripts of the Lives of the Saints," in *Francis Wormald: Collected Writings*, edited by J.J.G. Alexander, T. J. Brown, and Joan Gibbs (London, 1972), pp. 43–56.

56. See the essay by Kidd and Turner in this volume. Despite numerous observations to the contrary, the edges of the quire's pages are not noticeably more soiled than the other pages in the psalter. If this booklet did indeed have a separate life before being bound into the larger psalter, that is not visible through increased wear.

57. Michael Curschmann, "Pictura laicorum litteratura? Uberlegungen zum Verhältnis von Bild und volkssprachlicher Schriftlichkeit im Höch- und Spätmittelalter bis zum Codex Manesse," in *Pragmatische Schriftlichkeit im Mittelalter*, edited by Hagen Keller et al., Münster Mittelalter-Schriften 65 (Munich, 1992), pp. 211–29; Powell, "The Visual, the Visionary," pp. 343–45.

58. Meyer Schapiro, "The Image of the Disappearing Christ: The Ascension in Anglo Saxon Art around the Year 1000," *Gazette des Beaux Arts*, ser. 6, vol. 23 (1943), pp. 135–52; Robert Deshman, "Another Look at the Disappearing Christ: Corporeal and Spiritual Vision in the Early Middle Ages," *Art Bulletin* 79 (September 1997), pp. 519–46.

59. Kathleen M. Openshaw, "Weapons in the Daily Battle: Images of the Conquest of Evil in the Early Medieval Psalter," *Art Bulletin* 75 (March 1993), pp. 17–38.

60. For the use of the vernacular in the cloister, see Dominica Legge, *Anglo-Norman in the Cloisters* (Edinburgh, 1950); Ian Short, "Patrons and Polyglots: French Literature in 12th-Century England," *Anglo-Norman Studies* 14 (1992), pp. 229–49; Ian Short, "Verbatim et Literatim: Oral and Written French in Twelfth-Century Britain," *Vox Romanica* 68 (2009), pp. 156–68.

61. Thomson, "St Albans Psalter"; Powell, "The Visual, the Visionary," pp. 347–49.

62. Kidd, "Contents and Codicology," p. 125.

63. Geddes, *St Albans Psalter*, pp. 114–20.

64. Powell, "Making the Psalter," p. 306; Thomson, "St Albans Psalter."

65. Talbot, *Life of Christina*, p. 99.

66. Judith Oliver, "A Primer of Thirteenth-Century German

Convent Life: The Psalter as Office and Mass Book," in *Illuminated Psalter*, ed. Büttner, pp. 259–70.

67. Utrecht, Universiteitsbibliotheek, Ms. Bibl. Rhenotraiectinae I Nr 32; London, British Library, Harley Ms. 603.

68. Kidd, "Contents and Codicology," pp. 118–19.

69. Ibid., p. 95.

70. Saint Jerome, *Brevarium in Psalmos*, in *Patrologia Latina*, vol. 26, col. 881.

71. Noted on the University of Aberdeen St Albans website, http://www.abdn.ac.uk/stalbanspsalter/english/commentary /page117.shtml.

72. See the essay by Kidd and Turner in this volume.

73. Kidd, "Contents and Codicology," p. 97.

74. Nilgen, "Psalter der Christina von Markyate," no. 69, p. 163, first interpreted it as such, a reading since reinforced by Geddes, *St Albans Psalter*, p. 100. For the vision, see Talbot, *Life of Christina*, pp. 156–57.

75. Kidd, "Contents and Codicology," pp. 108–9.

76. Ibid., pp. 109–11.

77. Jane Geddes, "The Illustrations," in *St Albans Psalter*, commentary by Bepler, Kidd, and Geddes, p. 215.

78. Herbert L. Kessler, "Gregory the Great and Image Theory in Northern Europe during the Twelfth and Thirteenth Centuries," in *A Companion to Medieval Art: Romanesque and Gothic in Northern Europe*, edited by Conrad Rudolph (Malden, Mass., 2006), pp. 151–72; Curschmann, "Pictura laicorum litteratura?" pp. 211–29.

79. Camille, "Seeing and Reading," p. 32.

80. See Jeffrey Hamburger, "Before the Book of Hours: The Development of the Illustrated Prayer Book in Germany," in *The Visual and the Visionary: Art and Female Spirituality in Late Medieval Germany* (New York, 1998), pp. 184–90, especially p. 187.

81. Ibid., p. 184; C. H. Talbot, "The *Liber confortatorius* of Goscelin of Saint Bertin," *Analecta monastic* (Studia Anselmiana) 3 (1955), pp. 116–54.

82. Oxford, Bodleian Library, Ms. Gough Liturg. 2 (S.C.18343), ca. 1170. This cycle and its prayers are the subject of forthcoming studies by Peter Kidd and Martin Kauffmann.

83. Camille, "Seeing and Reading," pp. 28–29; Michael Clanchy, *From Memory to Written Record: England, 1066–1307* (Cambridge, Mass., 1979), pp. 214–18.

84. Malcom B. Parkes, "Reading, Copying and Interpreting a Text in the Early Middle Ages," in *A History of Reading in the West*, edited by Guglielmo Cavallo and Roger Chartier (Amherst, Mass., 1999), p. 92.

85. Camille, "Seeing and Reading," p. 28n17.

86. Carrasco, "Imagery of the Magdalen," p. 72.

87. Anselm of Canterbury, *S. Anselmi Cantuariensis archiepiscopi opera omnia*, edited by F. S. Schmitt (Edinburgh, 1946–61), vol. 3, p. 4; Fulton, *From Judgment to Passion*, especially pp. 170–92.

88. This damage was recently noted through the study of the manuscript under the microscope by Collins, Kidd, and Turner.

89. The first occurrence is found on p. 35, *The Third Temptation of Christ*. *The Flagellation* (p. 44) and *The Harrowing of Hell* (p. 49) contain similar holes. This kind of damage was not noted in any of the psalm initials.

90. For more on deliberate damage to medieval manuscripts, see Michael Camille, "Obscurity under Erasure: Censorship in Medieval Illuminated Manuscripts," in *Obscenity: Social Control and Artistic Creation in the European Middle Ages*, edited by Jan M. Ziolkowski (Leiden, 1998), pp. 139–54.

91. New York, Morgan Library & Museum, Ms. M.736, fol. 13v; Kauffmann, *Romanesque Manuscripts*, no. 34.

92. Herbert L. Kessler, "Evil Eye(ing): Romanesque Art as a Shield of Faith," in *Romanesque Art and Thought in the Twelfth Century: Essays in Honor of Walter Cahn*, edited by Walter Cahn and Colum Hourihane (Princeton, N.J., 2008), pp. 107–35, especially pp. 117, 135.

93. The identification of Harold as the figure pierced with an arrow through the eye in the Bayeux Embroidery remains controversial, but for a discussion of the use of blinding as punishment in post-Conquest England, see David J. Bernstein, *The Mystery of the Bayeux Tapestry* (Chicago, 1986), pp. 152–59; David J. Bernstein, "The Blinding of Harold and the Meaning of the Bayeux Tapestry," *Anglo-Norman Studies* 5 (1983), pp. 40–64.

94. Wace, *The History of the Norman People*, translated by Glyn S. Burgess, with notes by Glyn S. Burgess and Elisabeth van Houts (Woodbridge, Suffolk, 2004), especially p. 162.

95. New York, Morgan Library & Museum, Ms. M.736; London, British Library, Ms. Lansdowne 383; Kauffmann, *Romanesque Manuscripts*, no. 34, pp. 72–74, no. 48, pp. 82–84.

Materiality and Collaborative Enterprise in the Making of the St. Albans Psalter

Peter Kidd and Nancy K. Turner

THE ST. ALBANS PSALTER is arguably the most famous, extraordinary, and puzzling book produced in twelfth-century England. Yet after more than a century of study, scholars still disagree about its precise place in the history of art, language, literacy, and many other fields of study. In 2006 the volume was disbound to facilitate conservation, photography, and exhibition. This permitted the manuscript to be examined as never before.

Recent studies of the St. Albans Psalter have been distinctly colored by the authors' opinion of the intended user of the book: Christina of Markyate, Abbot Geoffrey of St. Albans, or the monastic community at either place. As this issue remains hotly contested, the approach here is to present the manuscript primarily as a physical object, avoiding its patronage or intended owner as a starting point.[1] We hope to reveal aspects of the materiality of the manuscript—its parchment, pigments, painting techniques, and physical manufacture—to promote a deeper understanding of these features so that they may be taken into account in future studies. In this essay, we consider what the materials used suggest about the making of the psalter. For example, was it indeed as exceptionally expensive to produce as has been assumed in the past? We also consider how the materials and techniques used may help determine the date of the book. We examine the work of various artists represented in the manuscript and the question of whether they worked independently or collaboratively. Finally, we look at the ways in which parts of the book relate to one another, addressing especially the hypothesis that the Alexis Quire was a separate booklet before being bound into the volume.

The Artists

Because there is no record of the names of most medieval craftsmen, art historians invent names for ease of reference. In modern publications it is generally agreed that four artists contributed to the St. Albans Psalter: the artist of the calendar has not been given a name, but for convenience he is referred to in this volume as the Calendar Artist; the painters of most of the historiated initials have been referred to, rather undescriptively, as Artist 1 and Artist 2;[2] and the primary artist of the manuscript has always been known as the Alexis Master[3] because, in addition to the prefatory picture cycle, he executed the decoration in the Alexis Quire. As will be discussed below, however, we have serious doubts about whether the artist of the Alexis miniature itself (see fig. 26) was responsible for the rest of the Alexis Quire and the prefatory cycle.[4] This creates an obvious problem: "Alexis Master" would be an unfortunate misnomer if he did not execute the Alexis miniature. Although it would therefore be logical to reserve the name "Alexis Master" for the author of the Alexis miniature and to invent a new name for the artist of the rest of the Alexis Quire and the prefatory cycle, such renaming would cause untold confusion among scholars. Thus the established name "Alexis Master" is used herein for the artist of the prefatory cycle, and he is distinguished from the artist of the Alexis miniature.

The Alexis Master is usually described as an itinerant professional,[5] in part because his compositions and his style, as evidenced in the St. Albans Psalter, occur in books made for other monasteries, including two for Bury St. Edmunds, one perhaps made in Dorset or Somerset, and one for Canterbury (discussed below). But did he travel around England, somehow influencing other artists with his style and iconography; did these other artists fall under his spell at St. Albans; or was there some other process of transmission?

The Alexis Master contributed to at least three surviving books written by St. Albans scribes, so it has been suggested that he was based at the abbey for ten or twenty years.[6] But if he was settled in one place for so long, can he really be considered itinerant? As it has been convincingly argued that his style is a development from earlier St. Albans manuscripts such as a *Psychomachia* manuscript in London (see fig. 6),[7] it is arguably more likely that he was a monk, perhaps taught by the artist whose style and figure types have so much in common with his own.

Material Evidence and Date of the Manuscript

While the recent scholarly debate over the date of the St. Albans Psalter has been based largely upon external evidence,[8] some material aspects might throw further light on the question. In manuscript studies generally, the style of the handwriting is often the only evidence for date. But how reliable is script as a specific indicator of date?

The evidence of a mortuary roll is particularly relevant to this question. In the Middle Ages, when an important person such as an abbot or bishop died,

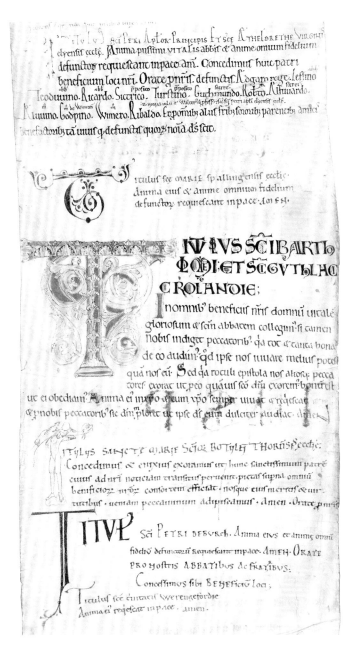

Fig. 50

Mortuary Roll of Abbot Vitalis
Inscriptions from various
places in England, written
and decorated by various
scribes, ca. 1123
Paris, Archives nationales,
AE/II/138, membrane no. 10v

Although all written within
a short space of time, the
inscriptions from different
monasteries show great variety
of script and decoration.

a mortuary roll (pieces of parchment joined top-to-bottom and rolled up like
a vertical scroll) might be circulated from monastery to monastery, at each of
which a scribe would add an inscription. Abbot Vitalis of Savigny in Normandy
died in 1122, and during the following year or two his mortuary roll accumu-
lated more than two hundred inscriptions.[9] Figure 50 shows the section of the
roll with the inscriptions added at Ely, Spalding, Crowland, Thorney, Peterbor-
ough, and Wallingford, some of which are within fifty miles of St. Albans (see
fig. 3). What is striking is how different the script and decoration of each one
are; throughout the roll, old-fashioned script appears alongside forward-look-
ing script, even though the inscriptions were often written within weeks of one

another. The mortuary roll also includes a St. Albans inscription,[10] but this consists of just sixteen words, and its scribe may have written in exactly the same way many years before or after 1123. This demonstrates why it is impossible to precisely date the St. Albans Psalter using its script alone.

External evidence is likewise equivocal. If the psalter was commissioned by Abbot Geoffrey either for Christina of Markyate, as is widely believed, or with her in mind,[11] then recent scholarship would indicate that it was made no earlier than about 1130, when they first met.[12] Some scholars believe that Geoffrey had the psalter made for his own use or for that of the abbey,[13] or that all features linking it to Christina are later additions.[14] It will therefore be worth scrutinizing the raw materials of the codex and its manufacture to see if they can shed any light on the vexed question of the psalter's date.

Parchment | Parchment consists of animal skin (typically calf for use in books, sheep for documents, and goat in Italy) processed by soaking in a lime bath to aid the removal of hair and fat, stretching on a frame, scraping thin, and drying under tension. It is then rubbed with a pumice to create a smooth surface on which to write. The quality of the parchment is a good indicator of the intentions of a bookmaker, even before the scribe and decorator begin to work. The parchment used to make the St. Albans Psalter is evidently calfskin, as characteristic veining and small areas of hair follicles are visible on some of the leaves.

The volume is not unusually long or large, so its parchment cost would not have been exceptional; it would probably have required between twenty-seven and fifty-four calfskins, perhaps closer to thirty than fifty, assuming that the makers got between two and four bifolia from each skin. But how difficult and expensive would it have been to produce or obtain this quantity?

In the twelfth century, parchment need not have been manufactured in a monastery; it could be obtained commercially. For a large-format manuscript such as a lectern Bible, high-quality parchment was required, as only a single bifolium could be cut from each skin, but for a smaller book the scribe could get away with cheaper skins, cutting around flaws. A set of monastic accounts from 1269–70 from southern England shows that prices per dozen sheets varied from 3d (d for pence) for the lowest-grade sheepskin to 30d for the highest-grade calfskin, ten times more expensive; other thirteenth-century records suggest that a typical price for calfskins was 1–2d each.[15] At these rates the parchment of the St. Albans Psalter would have cost between 30d and 60d. To put this into context, 60d was less than the cost of one day's food and drink for the monks during Geoffrey's abbacy.

In general, the quality of the parchment of the St. Albans Psalter is very good; flaws such as the holes and stitched repairs found below the miniatures of *The Journey of the Magi* and *The Magi before Herod* (see fig. 14) are rare. Some scholars have perceived marked differences in the parchment of the four main sections of the manuscript and concluded that they must have been made at

different times or even come from different manuscripts.[16] Our reexamination challenges such assertions.

With the volume disbound, it is easier to compare the parchment within and across quires. Its qualities were first assessed by touch and then measured using a precision micrometer. While individual leaves vary in thickness, the calendar, Alexis Quire, and psalms sections share a consistent range in thickness and surface texture. A significant difference could be detected in the prefatory cycle, however; its parchment is noticeably thicker than the rest, and the surface appears to be smoother overall. The use of a thicker parchment for miniatures was not unusual: in the New York *Life and Miracles of Saint Edmund* manuscript (see fig. 49), for example, bifolia are pasted back-to-back to create a double-thickness support for the full-page picture cycle.[17]

At least one scholar has asserted that the outer bifolium of the Alexis Quire is significantly dirtier than the others and suggested that this indicates that the quire existed without a protective covering, separate from the rest of the psalter, for a considerable period of time.[18] Again, our recent examination does not support this claim. While it is true that the outermost bifolium is dirtier than the inner ones, this dirt, which appears mainly in the lower outer corners, is doubtless due to handling by readers. If one compares the outermost bifolium with the outermost bifolia of the adjacent quires, one sees that the Alexis Quire is in fact less dirty than some of its neighbors (fig. 51).

Fig. 51
Outer Pages of Seven of
the First Seven Quires
St. Albans Psalter

The Alexis Quire is third
from the right.

Ruling | Like clothing or architecture, medieval bookmaking practices evolved and changed. One such change was from the practice of ruling the leaves with a hard, fairly sharp point, so that one side has a series of furrows and the other side has ridges, to ruling each page in lead point (plummet), so that each side has gray lines to guide the writing. This transition happened at different dates in different places, but within a single institution such as St. Albans it can be assumed that books made using the older practice are likely to predate those using the newer practice.

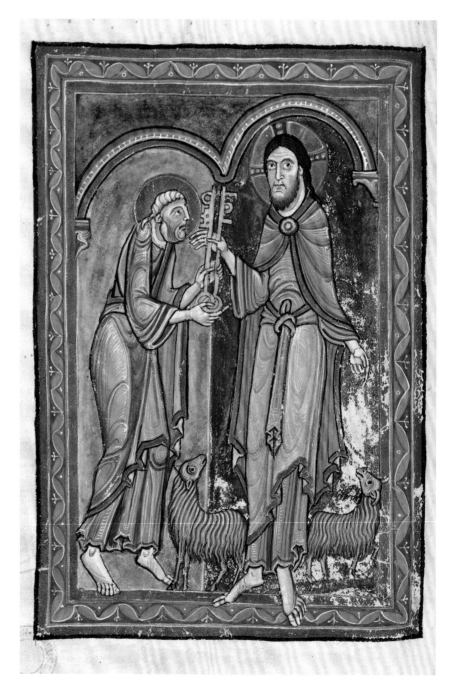

Fig. 52
Saint Peter Receiving the Keys of Heaven from Christ Saint Anselm, *Prayers and Meditations*
St. Albans, England, first half of the 12th century
Illuminated by the Alexis Master
Verdun, Bibliothèque de la codecom de Verdun, Ms. 70, fol. 68v

Fig. 53

Lines of Text from Psalm 138, Psalm 139, Initial *C* (detail) St. Albans Psalter, p. 355

The pricking and deeply scored vertical and horizontal ruling lines in this section of the manuscript are incorrectly ruled for double columns of twenty-five lines and do not correspond to the text as written.

Using this indicator, we would expect that the St. Albans Psalter, partly ruled with a hard point, is likely to predate the copy of Saint Anselm's *Prayers and Meditations*, written by a St. Albans scribe and illuminated by the Alexis Master (fig. 52), which is ruled in plummet.[19] This manuscript, now in Verdun, France, is itself not reliably dated, but one hypothesis to explain its centuries-old presence in Verdun is that it was taken there by Henry of Blois, brother of King Stephen of England and bishop of Verdun from 1120 to 1129. If this hypothesis were true, it would presumably date from before 1129, when Henry resigned that bishopric to become bishop of Winchester.

The most surprising feature of the St. Albans Psalter's parchment as a whole is that, unlike the majority of the book, which is ruled in a very faint plummet for a single column of twenty-two lines, four quires at the end were ruled with a hard point for double columns of twenty-five lines (see fig. 41).[20] The ruling of these four quires is also far deeper than the rest, making it more difficult for the scribe to write on (fig. 53). There seem to be only two ways to account for the mismatched quires. Either they came from a supply of ready-ruled parchment left over from another project, or they were ruled incorrectly by the makers of the psalter. In either case, it seems that the scribe or patron could not afford the time or money necessary to obtain more parchment. Thus clear physical evidence suggests that haste, parsimony, or both were significant factors in the making of the book.

Fig. 54
Psalm 105, Initial *C*
(Christina Initial)
St. Albans Psalter, p. 285

The transmitted light
photograph of the parchment
patch reveals thinned areas due
to scraping of the page.

Fig. 55
Psalm 105, Initial *C*
(Christina Initial) (detail)
St. Albans Psalter, p. 285

The photomicrograph of the
lower edge of the glued-in
piece of parchment shows
scraping marks and the re-
inked adjacent text.

The Christina Initial | The so-called Christina Initial (see fig. 10) is executed on a separate piece of parchment glued into the manuscript. It has long puzzled scholars, who wondered why a blank space might have been left here and, if a blank space had been left, why an extra piece of parchment was required for the initial. Or, if a former initial was erased to make way for the present one, why was a patch also added?

Neither backlighting nor infrared imaging reveals any trace of an initial underneath the parchment patch, but abrasions are clearly evident around the lower and right edges (fig. 54). Under magnification, traces of bole from the gold of a previous initial can be detected at the lower right corner and lower edge, and these traces are identical to the bole used for the gilded initial on the conjoint leaf. In addition to this evidence, perhaps the clearest indicator that a former initial was erased is the re-inking of letters of the text around the patch (fig. 55), which must have suffered abrasion. The parchment patch was necessary because

the erasure would have left a rough surface and an unsuitably thin and porous area on which to paint. A blank parchment patch was then pasted in place and its designs painted on the double layer of parchment.

Pigments | Twelfth-century aesthetics were driven by the lure of brilliant rich color: as William of Malmesbury remarked on the newly completed paintings at Lanfranc's cathedral at Canterbury, "In the multi-colored paintings an admirable art ravished the heart by the alluring splendor of the colors and drew all eyes to the ceilings by the charm of its beauty."[21] The distinctive palette and the use of color in the St. Albans Psalter are among its most notable features. A recent preliminary study of the pigments was performed using noninvasive, nondestructive methods.[22] Inorganic pigments (both mineral based and chemically synthesized) identified in the psalter include ultramarine, vermilion, orange-hued red lead, lead white, carbon black, yellow ocher, and a (not yet identified) copper-corrosion-product green. Given the abundance of recipes for green found in early-medieval technical treatises, many methods for making green pigments from copper must have existed; these are reflected in the variability in hue and the differing states of preservation of the greens in the psalter and contemporaneous manuscripts. Organic dyestuff colorants are among the best preserved and most striking in the psalter. An organic pink was identified as probably being the insect dye kermes.[23] The deep organic purple used in the backgrounds was identified as possibly either folium or a lichen dye.[24]

The mineral blue used throughout the psalter is ultramarine, which is extracted through repeated labor-intensive steps from lapis lazuli stones, imported from present-day Afghanistan. The stones contain lazurite together with other associated minerals,[25] which are progressively removed with each iteration of the refining process. Ultramarine has been extensively identified in wall paintings dating from about 1090 to about 1190 in England at Lewes Priory, Glastonbury Abbey, and the cathedrals of Canterbury, Winchester, Durham, and Norwich, and in Ireland at Cashel, suggesting that during this period it may not have been as expensive or hard to procure as is generally believed.[26] In all the leaves of the psalter that were examined, the ultramarine was found to contain the mineral impurities associated with a relatively unrefined lapis lazuli, indicating, perhaps, that a comparatively inexpensive form of the pigment was used.[27]

These pigments, fewer than a dozen, appear to have been used in different mixtures and layer combinations to create a wider, more varied range of hues than if they had been used individually. They are all materials that were widely available to twelfth-century English illuminators, either produced locally or imported through an international network of fairs and markets. As yet, no marker pigments have been identified that are characteristic enough to distinguish among the different painters, painting techniques, or quires of the psalter, but more analysis remains to be done.

Gold | The extensive use of gold leaf in the St. Albans Psalter creates the impression that it was a very costly object to make. Close examination of the gold is especially fruitful for two reasons: it gives an unexpected insight into the patron's attitude to expense, and it may also be an important clue to the relative chronology of the psalter and related manuscripts.

Although the earliest description for the manufacture of gold leaf is in a text from about 800, and Theophilus's early-twelfth-century treatise *On Divers Arts* includes instructions for manufacturing and applying gold leaf to wood panels and walls,[28] the use of gold in manuscripts does not seem to have become common in England before the mid-twelfth century. Theophilus's instructions for using gold in books involves powdered gold, not gold leaf; he describes how it should be ground, applied, and burnished.[29] In a Gospel Book in Hereford, for example, written partly by a St. Albans scribe and illuminated by the Alexis Master, gold paint is used to outline the initials, in the double framing lines, and in the halos in miniatures (fig. 56).[30]

The transition from using gold paint to using gold leaf in manuscripts was surely motivated by the fact that gold leaf gave the appearance of a thick layer while using, in fact, less gold. A single gram of gold can produce enough gold leaf to cover two square yards, probably more than used in the entire psalter.

The application of gold leaf requires that a base layer of bole be painted onto the parchment. In the psalter, a single layer of gold leaf (not multiple layers, as Theophilus suggests[31]) is adhered to a thin and flat layer of bole consisting of yellow ocher or red ocher (both iron oxides). After application, the gold leaf can be burnished to a shine. In the psalter, a black or white outline delimits the otherwise rough edges of the gilding, giving a neat appearance to the finished work.

Fig. 56
Saint Mark Writing (detail)
Gospel Book
St. Albans(?), England, first
half of the 12th century
Illuminated by the Alexis
Master
Hereford, Cathedral Library,
Ms. O.I.8, fol. 45v

Note the granular gold paint
in the framing outlines and
the halo.

Fig. 57
The Second Temptation of Christ (detail)
St. Albans Psalter, p. 34

Christ's halo shows pieced gold leaf.

Fig. 58
The Third Temptation of Christ (detail)
St. Albans Psalter, p. 35

The photomicrograph shows individually applied pieces of gold leaf.

Fig. 59
The Entry into Jerusalem (detail)
St. Albans Psalter, p. 37

The photomicrograph of Christ's garment shows fold lines indicated with an unusual raised bole below the gold leaf.

Fig. 60
Beatus Initial (detail)
St. Albans Psalter, p. 72

The photomicrograph of gold leaf shows gold applied to bole on top of a green-painted area.

57

58

59

60

Theophilus's instructions produce sheets of gold leaf "four fingers wide and equally long."[32] The normal practice was to use only as much of such a sheet as necessary to cover the entire area to be gilded; the gold adheres to the bole and the rest can be brushed away and recycled. In the psalter, by contrast, a different method sometimes appears to have been used. Very small, precisely cut pieces of gold leaf appear to have been carefully applied to the bole, leaving seams and square-cut edges visible. This technique can be seen especially in the prefatory cycle, where the gilding is confined to the framing elements and to details within the images such as halos and crowns (fig. 57), architectural elements, and the treasures laid at Christ's feet (fig. 58). The nimbus of the angel in *The Resurrection* and Christ's halo in *The Entry into Jerusalem* are exceptions: these elements are ornamented with circlets painted with a thick bole onto a flat ground before larger pieces of gold leaf were applied. In *The Entry into Jerusalem*, Christ's mantle was similarly gilded over an even larger area, its folds rendered with a raised dark yellow ocher bole (fig. 59).

No gold was used in the calendar or the Alexis Quire, except as an addition to the Beatus Initial (see fig. 29). Here the ground for the gold is consistent with the ocher-based grounds used throughout the rest of the manuscript, yet it was applied on top of the painted colors of the initial (fig. 60). This execution suggests that both bole and gold were an afterthought, but there is no technical evidence indicating that it was done as a separate process or at a date different from that of the gilding in the prefatory cycle and the psalms section.

Thus in the psalter as a whole, the application of gold leaf was labor-intensive yet parsimonious, especially when compared to the gilding used, for instance, in the Bury and Dover Bibles, where the gilded elements were not built up with

Fig. 61
Edmund Crowned the King of East Anglia (detail)
The Life and Miracles of Saint Edmund
Bury St. Edmunds, England, first half of the 12th century
New York, Morgan Library & Museum, Ms. M.736, fol. 8v

Gold leaf was cut into small, narrow pieces for the architectural details.

Fig. 62
Saint Peter Receiving the Keys of Heaven from Christ (detail)
Saint Anselm, *Prayers and Meditations*
St. Albans, England, first half of the 12th century
Illuminated by the Alexis Master
Verdun, Bibliothèque de la codecom de Verdun, Ms. 70, fol. 68v

Metallic (probably brass) paint was used in the halo, not gold leaf.

small pieces, giving a richer, more brilliant effect.[33] Interestingly, the use of small pieces of gold leaf in the St. Albans Psalter is the same as that in the New York *Life and Miracles of Saint Edmund* (fig. 61; see also fig. 49), whose long prefatory cycle has often been attributed to the Alexis Master. The gilding in both books seems to emulate the linear effects of painted, granular gold ink seen in the Gospel Book in Hereford (see fig. 56).

In the Verdun *Prayers and Meditations* of Saint Anselm, the Alexis Master used a pseudo-gold paint for the initials and the miniature (fig. 62; see fig. 52). Its dark, somewhat less reflective appearance and a distinctive show-through green color on the reverse side of the leaf suggest that brass paint may have been used instead of the probably pure, elemental gold paint used in the Hereford manuscript.[34]

Various gilding techniques may help place the St. Albans Psalter and other closely related manuscripts within a relative chronology. It may be that those using granular gold or metallic inks are earlier than those using gold leaf. Or they may all occupy a transitional period when practices were changing, in which case the gilding technique cannot be used as an indicator of date. But if so, perhaps gold leaf was used tentatively and experimentally in the St. Albans Psalter, as a cost-saving alternative to the more familiar powdered gold.

Painting Techniques

A variety of painting techniques—often inaccurately described as styles—were used in England after the Norman Conquest, including drawing in colored inks, partial color tinting, and full-color painting.[35] For illuminations with partial tinting, pigments were applied alongside the drawn line, leaving the parchment visible to act as the highlights and light areas (including backgrounds). Colors were diluted in varying proportions to give a gradation to the tinting, allowing the parchment to show through. For fully painted illuminations, opaque pigments, including opaque white paint, were applied in successive layers to build up the design, leaving little or no bare parchment visible. The visual effect was one of deeply saturated, vibrant colors in contrasting fields.

That different painting techniques are found in the different sections of the St. Albans Psalter has caused commentators to speculate about the original intentions of its makers: is the manuscript a composite book of disparate, separately made parts? More specifically, were the calendar section (see figs. 11, 12) and the Alexis Quire (see figs. 26–28)—both executed almost exclusively in a tinted drawing technique—originally made to go with the rest of the fully painted manuscript? If so, what could explain the differences in painting techniques among the sections?

Manuscripts that have been attributed to the Alexis Master employ a range of techniques: the Gospel Book in Hereford has a fully painted and gilded miniature and initials (see fig. 56), as well as one initial partially tinted without gold

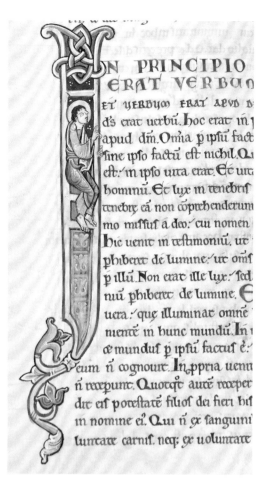

Fig. 63
Saint John the Evangelist,
Initial *I*
Gospel Book
St. Albans(?), England, first
half of the 12th century
Illuminated by the Alexis
Master
Hereford, Cathedral Library,
Ms. O.I.8, fol. 113v

Fig. 64
Initial *I*
Priscian, *Institutiones
grammaticae*
St. Albans, England, first
half of the 12th century
Leiden Universiteitsbiblio-
theek, Ms. BPL 114 B,
fol. 147v

(fig. 63). The Leiden Priscian, written by a St. Albans scribe and perhaps deco-
rated by the Alexis Master, combines the colored-line drawing technique with
tinted drawing (fig. 64),[36] as does the Bede *Song of Songs* manuscript, also written
at St. Albans and decorated in a related style (fig. 65).[37] The mid-twelfth-century
Pembroke Gospels, which was (like the New York *Saint Edmund* manuscript)
made for Bury St. Edmunds (see fig. 3), is intimately related to the St. Albans
Psalter in its iconography and has partially tinted miniatures preceding a text
block with fully painted initials.[38] Even within the psalter, more than one tech-
nique is often used on a single page (see fig. 1), and one of the initials is executed
mainly in a tinted technique (fig. 66). Faces in the psalm initials as well as in the
prefatory miniatures are often painted in such a way that bare parchment acts
as the flesh tone, with partial tinting of green pigment around the eyes, mouth,
and chin and with finely painted touches of white and red to give highlights and
colored modeling to the face (see below). The use of different techniques within
illuminations appears to have been intentional, the result of deliberate experi-
mentation or emulation of other parts of the manuscript.

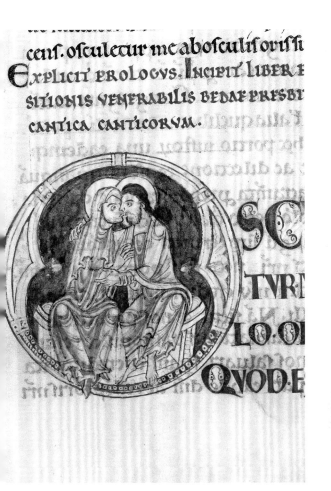

Fig. 65
The Bride and Bridegroom
Bede, *Commentary on the
Song of Songs*
St. Albans, England, first
half of the 12th century
Cambridge, King's College,
Ms. 19, fol. 21v

Fig. 66
Psalm 106:25, Initial *D*
St. Albans Psalter, p. 292

The figures painted by Artist 2
show faces executed in the
tinted-drawing technique
against full-color backgrounds.

The Painting of the Psalm Initials | Normally, before painting, the design of each initial was sketched with faint pencil-like lead-point (plummet) drawings. These established the general character of the letterform and specific design elements within it, such as the main figures. These drawings were then traced with pen and ink to strengthen the main outlines. A ruler and compass might also be used, especially for architectural elements and for circular features such as halos. Romanesque drawings often exhibit an extraordinary mastery and confidence, perhaps resulting partly from this two-step drawing method. The typical ink for both writing and drawing on parchment at this time was made from crushed oak galls mixed with an iron-containing compound. Pale gray when first mixed, it turns black if allowed to stand in the open air. Over time it turns brown and can fade. In the St. Albans Psalter, the sketches were made in lead-point (now barely visible), then inked over in iron gall ink (now pale brown). As discussed below, the ink drawings can be revealing in more ways than one.

With the exception of the Beatus Initial (see fig. 29) and the added Christina Initial (see fig. 10), the initials appear to have been drawn by the Calendar Artist in iron gall ink.[39] They are generally thought to have been painted by two artists. It is easy to see why. Those for Psalms 1–13 are rather homogeneous in style,

Fig. 67
Psalm 9:1, Initial *C*
St. Albans Psalter, p. 84

The figures painted by Artist 1
show characteristic white-
painted faces with green chin
straps and bold, striped drapery.

Fig. 68
Psalm 9:1, Initial *C* (detail)
St. Albans Psalter, p. 84

The photomicrograph of a
face painted by Artist 1 shows
characteristic white paint and
green shading lines.

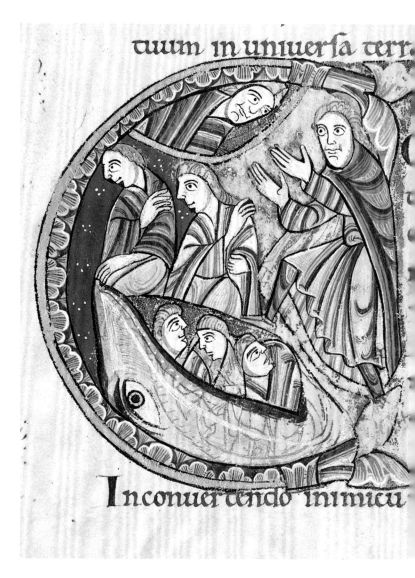

characterized by extensive use of orange and red, striped draperies, backgrounds
in which the blue and green are frequently worn away, and faces painted in a
predominant white, with a green line at the chin (figs. 67, 68). From Psalm 14
forward, however, there is a very different aesthetic. A background of deep, rich
blue pigment contrasts starkly with the deep red used for both halos (a feature
not encountered before this point); orange-red is absent, replaced with yellow
ocher and deeper reds (figs. 69, 70). It is natural to conclude that a different
painter was responsible.

Various scholars have attempted to divide the initials into two groups.[40] After
acknowledging many similarities of figure and facial types, body proportions,
palette, and details of eyes and noses, Jane Geddes noted that the two artists
differed fundamentally in their handling of color: Artist 1 used more translu-
cent colors (or else the paint has simply worn away), revealing a disregard for
underdrawings. Drapery was rendered by flat bands of color, and no attempt

Fig. 69
Psalm 14, Initial *D*
St. Albans Psalter, p. 94

The figures painted by Artist 2
show characteristic partially
tinted faces and decorative,
shaped white drapery
highlights.

Fig. 70
Psalm 14, Initial *D* (detail)
St. Albans Psalter, p. 94

The photomicrograph of the
face painted by Artist 2 reveals
the partial tinting technique
with bare parchment showing
through.

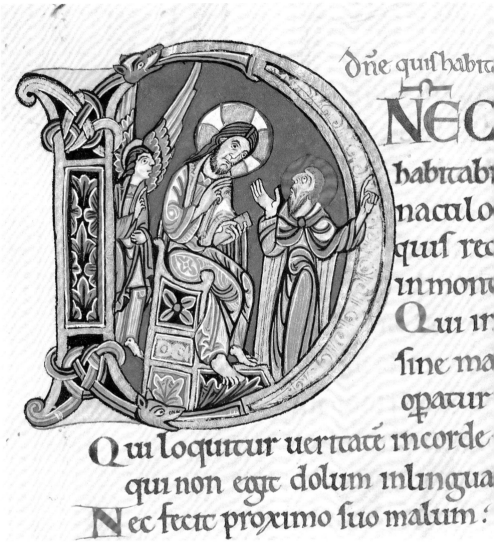

Fig. 71
Psalm 23, Initial *D* (detail)
St. Albans Psalter, p. 113

The photomicrograph of the
face painted by Artist 2 reveals
the partial tinting technique
with scumbled application of
red and white pigments on
bare parchment.

Fig. 72
Psalm 61, Initial *N* (detail)
St. Albans Psalter, p. 189

The photomicrograph of the
face painted by Artist 2 shows
multiple strokes of red, white,
and green on bare parchment.

Fig. 73
Psalm 129, Initial *D* (detail)
St. Albans Psalter, p. 341

The photomicrograph of the
face shows that the brown ink
underdrawing was left largely
unpainted.

Fig. 74
Psalm 68:17, Initial *E* (detail)
St. Albans Psalter, p. 204

The photomicrograph of the
initial painted by Artist 1
shows the face only partially
painted with white and the
typical green chin strap,
with areas of bare parchment
visible.

71

72

73

74

was made at facial modeling except for schematic green bands or a narrow green
"chin strap" over flat white paint for the faces (see fig. 68).[41] Artist 2, on the other
hand, made greater use of a partial tinting technique in the faces, with scumbled
touches of red, white (fig. 71; see also fig. 70), and occasionally green over the
flesh tone of the bare parchment (fig. 72). He modeled white drapery highlights
into shaped or decorative patterns, as on Christ's thigh (see figs. 34, 69).

These criteria provide one way of distinguishing the painting of various ini-
tials, such as those in the first quire of the psalms from those in the second. But
they do not cover all cases: there are initials where no paint was applied to faces
(fig. 73); others where faces were only partially painted in the pure white manner
with the green chin strap typical of Artist 1 (fig. 74); and others where faces were
essentially presented in the pure white manner characteristic of Artist 1 but with
a subtle application of color or white-on-white to create a more sophisticated
modeling that one might expect only of Artist 2 (figs. 75, 76). In short, many ini-

75

76

Fig. 75
Psalm 65, Initial *I* (detail)
St. Albans Psalter, p. 195

The photomicrograph of the face painted in the manner of Artist 1 with the green chin strap shows the white-on-white modeling that is more typical of Artist 2.

Fig. 76
Psalm 94, Initial *V* (detail)
St. Albans Psalter, p. 263

The photomicrograph of the initial painted by Artist 1 reveals the face showing the partial tinting technique more typical of Artist 2.

Fig. 77
Psalm 51, Initial *Q* (detail)
St. Albans Psalter, p. 173

The figures are painted by Artist 2, but the face of Christ is painted in a technique more typical of Artist 1.

77

tials do not fall neatly into either of the two stylistic categorizations. The distinctions become even more unsatisfactory when one takes into account nonfacial features such as the draperies. The use of purely decorative white patterns on draperies, described above, was not restricted to initials attributable, based on the painting of faces, to Artist 2: the initials for Psalms 14 (see fig. 69) and 51 (fig. 77) have faces painted in very different ways and were thus attributed by Geddes to two different artists but by C. R. Dodwell to a single artist, perhaps because both initials employ the same distinctive drapery effect of patterned white highlights.[42]

Several explanations might be given to account for this variety and apparent inconsistency in the painting technique of the faces. At one extreme one could propose that all the initials were painted by a single artist who simply varied the faces, draperies, palette, and so forth throughout. This idea is hypothetically possible, except that there appear to be different attitudes displayed by the painters to the drawn designs that they were overpainting. In particular, Artist 1 seems more likely than Artist 2 to have disregarded the details of the drawn design (see below). At the opposite extreme one could imagine that there were three, four, five, or more painters at work, using overlapping styles and techniques, making it impossible to correctly divide the initials into just two groups. While possible, Occam's razor encourages one not to suggest a large team of painters if a small one will fit the evidence. We propose an intermediate third hypothesis

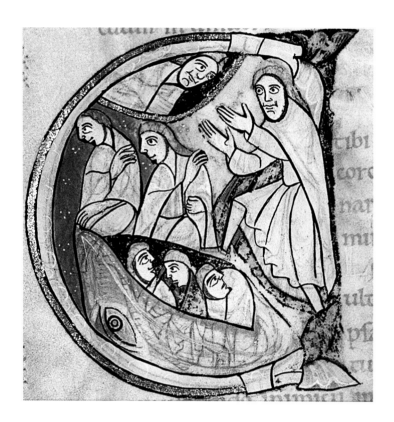

Fig. 78

Psalm 9:1, Initial *C*
St. Albans Psalter, p. 84

The infrared image shows extensive underdrawing, including a hand of God at the top left (overpainted) and a wider hellmouth with more figural details originally drawn at the bottom center.

based on what we see is a lack of clear division between the hands in the psalm initials: that there were two principal painters but that they did not divide their work strictly and they indulged in considerable experimentation and variation, perhaps occasionally emulating each other in various ways and sometimes collaborating on individual initials.

There are numerous later medieval examples of individual pictures in manuscripts being worked on by more than one painter, the Winchester Bible being a prime example.[43] Assuming a similar process for the St. Albans Psalter, with initials occasionally being started by one painter and finished by another, we might account for the bewildering variety found in the initials.

Deviations in Design | Generally in manuscript production, if the person making the initial underdrawing was the painter, it stands to reason that he would typically follow the drawing closely when painting over it.[44] When pentimenti are found, they usually betray only minor adjustments, such as straightening a hemline or changing the angle of a foot or an arm.

A striking feature of the historiated initials in the St. Albans Psalter, as has often been noted, is that the painting frequently does not follow the underdrawing.[45] Presumably any painter who ignored major parts of the ink designs was not responsible for those underdrawings. A number of pentimenti are visible due to losses of the background pigments, and others are visible using transmitted light. For instance, the alpha and omega letterforms drawn onto an open book

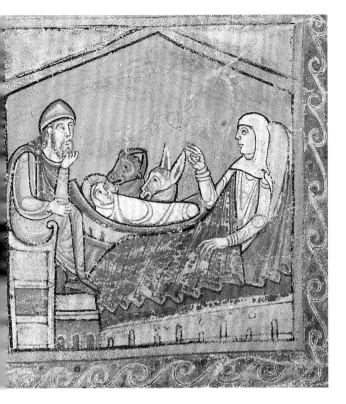

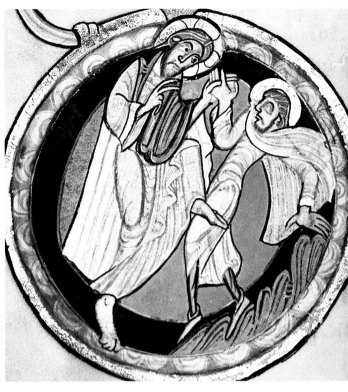

Fig. 79
The Nativity
Single leaf from the Eadwine Psalter (detail)
Canterbury, England, third quarter of the 12th century
New York, Morgan Library & Museum, Ms. M.724v

An angel with a censor drawn at the top center has been overpainted with the pink background color.

Fig. 80
Psalm 59, Initial *D*
St. Albans Psalter, p. 186

The infrared image shows how Artist 2 closely followed the underdrawing when painting, with only one drawn line not followed in the painting stage (in the left arm of the figure at the right, from elbow to shoulder).

for Psalm 53 were painted over with thick white pigment.[46] But with infrared imaging, the ink-drawn lines of the initial letters can be more fully revealed. For Psalm 9:1 (fig. 78), the painter simplified the hellmouth, which had originally been drawn with teeth and nostrils (ignored when painted with yellow ocher pigment and the white highlighting on top) and had originally been opened wider to reveal the twisted poses and feet of the figures within. He also painted over God's open hand at upper left, cloaking it in an orange-striped robe. The most significant instances of deviation all seem due to one painter, characterized above as Artist 1, who appears to be the lesser—or more hurried or careless—talent.

A comparable situation occurs in the prefatory picture cycle of the Eadwine Psalter, produced at Canterbury in the third quarter of the twelfth century, now divided between New York and London.[47] In *The Nativity*, for example, a detailed drawing of a censing angel has been overpainted completely with the pinkish background color (fig. 79), possibly because the angel is absent from the biblical accounts of the Nativity. Conversely, in the St. Albans Psalter *Nativity* scene the angel is present, but the star of Bethlehem has been overpainted (see fig. 15).

Artist 2 in the St. Albans Psalter, by contrast, meticulously followed the drawn designs, for example in the initial for Psalm 59 (fig. 80), and enlivened them with his own particular traits, such as the use of patterned white highlights and a more complex interpretation of form and figural interaction. In this image, the artist closely followed the underdrawing. The only underdrawn line that differs from

81

82

83

84

Fig. 81
The Legend of Saint Martin
(detail)
St. Albans Psalter, p. 53

Fig. 82
The Supper at Emmaus (detail)
St. Albans Psalter, p. 70

Fig. 83
Psalm 55, Initial *M* (detail)
St. Albans Psalter, p. 180

Fig. 84
Psalm 105, Initial *C* (Christina
Initial) (detail)
St. Albans Psalter, p. 285

the paint layer in the infrared image (see fig. 80) is the line of the figure's arm (from shoulder to elbow) at far right, which is covered by the fluttering cloak. This painter's respect for the underdrawing is clear and contrasts markedly with that of Artist 1. Thus a distinction can perhaps be made between the painters by their attitude to the underdrawings. It is possible to imagine that the Calendar Artist, responsible for the underdrawings in the psalm initials, and Artist 2 may be one and the same.

Formulaic Techniques | Medieval technical treatises such as Theophilus's *On Divers Arts* provide prescriptions for painting specific design elements, including particular pigment mixtures and the proper layering of them to achieve the desired effects. There are, for example, step-by-step instructions or formulas for how to paint faces.[48] Such guides may have been used as a starting point, and by their adaptation—in the choice of pigments and handling of painting technique—the individuality of the artist is revealed.

Whether they learned from such a manual or from a teacher, the different painters in the St. Albans Psalter appear to have followed a formula in their painting of faces. The Alexis Master built up the features of the front-facing Christ, for example, with the bare parchment serving as the flesh tone. He used green to create shadows in the eye sockets and arches of the eyebrows, around the chin and mouth, and along the side of the nose; fine touches of red to give color to the cheeks, lips, forehead, and neck; and white to add highlights in the eyes, along the nose, around the mouth, and on the forehead (fig. 81). He also used this formula when working in a partial tinting technique, using green and red only on the bare parchment without the addition of white highlight (fig. 82). This general formula appears to have been followed or imitated by Artist 2, but with a less delicate touch. With the bare parchment as the flesh tone, he used scumbled strokes of white and red and sometimes green to model and shade the face (fig. 83). A similar approach was taken for Christ in the Christina Initial, but with a thinner, dryer handling of the pigments (fig. 84). In all these examples, individual hands and personalities are evident, even though they all use essentially the same formula.

A formulaic approach is evident in the related manuscripts already mentioned. For instance, Saint Peter's profile face in the Verdun Anselm was rendered with a color combination similar to that found in the St. Albans Psalter but painted with broader, sweeping strokes to emphasize the three-dimensional facial structure (fig. 85). By contrast, in the New York *Saint Edmund* manuscript the formula is simpler than in the Verdun Anselm: unblended touches of blue or green pigment were painted around the eye sockets, with touches of red or orange along the nose and at the lips, chin, and forehead, quick strokes of white in the forehead and the whites of the eyes, and a dark red chin strap to delimit the jawline (fig. 86). The application of pigments in the New York *Saint Edmund*

85

86

87

88

Fig. 85
Saint Peter Receiving the Keys of Heaven from Christ (detail)
Saint Anselm, *Prayers and Meditations*
St. Albans, England, first half of the 12th century
Illuminated by the Alexis Master
Verdun, Bibliothèque de la codecom de Verdun, Ms. 70, fol. 68v

Fig. 86
The Arrested Thieves before Theodred of London (detail)
The Life and Miracles of Saint Edmund
Bury St. Edmunds, England, first half of the 12th century
New York, Morgan Library & Museum, Ms. M.736, fol. 19

Fig. 87
The Massacre of the Innocents (detail)
St. Albans Psalter, p. 30

Fig. 88
The Supper at Emmaus (detail)
St. Albans Psalter, p. 70

Fig. 89
Scenes from the Life of Saint Alexis (detail)
St. Albans Psalter, p. 57

manuscript may lack some of the refinement of the Alexis Master's work seen in the Verdun Anselm (see fig. 85) and the St. Albans Psalter (figs. 87, 88), a difference that has prompted scholars to ascribe only the drawing to the Alexis Master and the painting to a lesser artist. But it might be argued here that the application of colored strokes used in the New York *Saint Edmund* manuscript has its closest equivalent with that in the Alexis miniature in particular, where a shorthand method of coloring the faces was also used (fig. 89). Perhaps the *Saint Edmund* manuscript and the Alexis miniature share the closer relationship, especially in the painters' interpretations of the formulas for painting faces. We alluded above to differences between the Alexis miniature, on one hand, and the other miniatures in the St. Albans Psalter usually attributed to the Alexis Master, on the other. Likewise, scholars have long been aware of differences between the Alexis Master's work in the St. Albans Psalter and the painting of the miniatures of the New York *Saint Edmund* manuscript. The possibility that the master of the Alexis miniature was a distinct personality, responsible for the *Saint Edmund* manuscript, deserves to be explored further.

Collaboration

It is not uncommon to find more than one style or painting technique within a twelfth-century manuscript, and in these cases different artists may have been responsible. For instance, in a two-volume St. Albans manuscript of about 1125, six to eight artists have been posited.[49] This collaborative practice is especially evident in a large-scale project such as the St. Albans Psalter, in which the different styles or techniques correspond to different quires. One scribe may have passed quires to one or other artist as he finished writing them, or a completed text may have been distributed among a number of decorators so that they could work simultaneously. Although produced some decades later than the St. Albans Psalter, the Winchester Bible is another particularly revealing case because so many people were involved in its decoration and many different forms of collaboration can be observed. Some of the same individuals also worked on manuscripts for St. Albans. Underdrawings by one artist were painted by another; painters partially deviated from the underdrawings; and the completion of a single initial itself may have been the work of more than one painter. The process evident in the Winchester Bible has been termed "collaborative enterprise,"[50] although the specific nature of that collaboration may differ from that of the St. Albans Psalter.

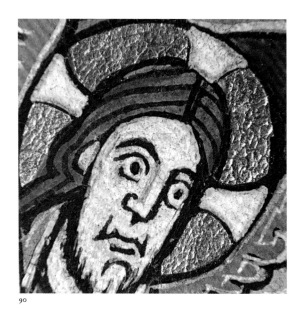

90

91

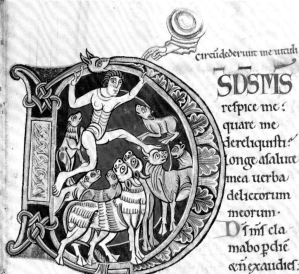

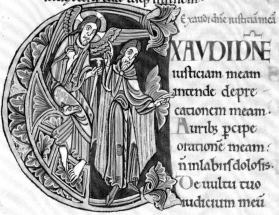

92

Fig. 90

Psalm 16, Initial *C* (detail)
St. Albans Psalter, p. 96

The face was painted by
Artist 2 using an atypical pink
flesh tone.

Fig. 91

Psalm 21, Initial *D* (detail)
St. Albans Psalter, p. 109

The face was painted by
Artist 2 using an atypical flesh
tone and was modeled with
green and white strokes.

Fig. 92

Psalms 16 and 21, Bifolium
with Initial *C* and Initial *D*
St. Albans Psalter, pp. 96, 109

The practice of collaborative painting at St. Albans is recorded in the early thirteenth century: the St. Albans monk, artist, and chronicler Matthew Paris (ca. 1200–1259) describes some paintings that "were executed, partly by his, partly by his father's hand," that is, partly by Walter of Colchester's brother, Simon, and partly by Simon's son.[51] Such a practice of collaboration within a single painting may have been far more common than previously believed. In addition, this family group reflects on the question of professional itinerant artists versus resident monks: Walter was a professional artist before becoming a monk, and his brother Simon must presumably have been a married layman when he had his son. The St. Albans chronicle also relates that in Abbot Geoffrey's time the greatest craftsman at St. Albans was Anketil, a Danish metalworker who was hired to make a new shrine for Saint Alban's relics in the 1120s and later became a monk.[52]

All scholars agree that several artists contributed to the St. Albans Psalter, but the details may never be fully worked out. It may not be possible, for example, to distinguish between a situation in which two artists cooperatively shared the work on a manuscript and one in which an artist completed work that another had abandoned and left partly or completely unfinished. As noted above, there are areas where one artist completed either the entire quire, as with the Calendar Artist in the calendar (quire 1) and the Alexis Master in the prefatory cycle (quires 2, 3, and 4), or images on individual bifolia within a single quire. The obvious change of painter at Psalm 14 described above (see fig. 69) coincides with the end of the first quire of the psalms and the start of the second. Furthermore, within this second quire the two initials that have a unique pink flesh tone for the faces (figs. 90, 91) are both on one side of the same bifolium. This observation confirms one aspect of the working method, namely, that a painter worked with an open bifolium before him (fig. 92), painting all its initials (if there were more than one) using the same batch of pigments handled in the same way. In these cases (e.g., quires 1–9), the working process appears to have been fairly straightforward. But by quires 10 and 11, a hybrid of painting techniques becomes apparent to the viewer. The techniques of both Artist 1 and Artist 2 can be identified on the same bifolium and sometimes within the same miniature, as if the sheets were being passed between painters and the images of one painter were being finished by the other.

In addition, in the process of collaborating, each painter seems to have taken a turn emulating the work of the other. For instance, in the initial for Psalm 51 by Artist 2 (see fig. 34), the painting of faces seems to combine his approach to modeling with the technique of Artist 1: in the faces at right, tints of red and green do not model the bare parchment, as is typical of Artist 2, but are painted over a broadly applied white pigment with a thick chin line in green more typical of Artist 1. In the same miniature, Christ's face is painted only with the solid white pigment more typical for Artist 1 (see fig. 77). Either both painters worked on the faces in this initial, or Artist 2 emulated Artist 1 in this instance.

91

93

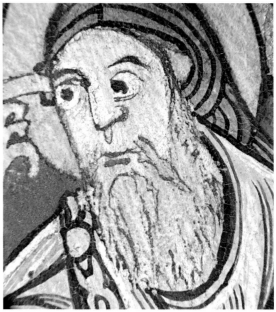

94

Fig. 93
Psalm 42, Initial *I* (detail)
St. Albans Psalter, p. 156

Note the blue paint applied to
the beard of the figure.

Fig. 94
Psalm 43, Initial *D* (detail)
St. Albans Psalter, p. 157

Note the blue paint applied to
the beard of the figure.

Fig. 95
Psalm 36, Initial *N* (detail)
St. Albans Psalter, p. 140

Note that a pass of blue paint
was not applied to the beard of
the figure.

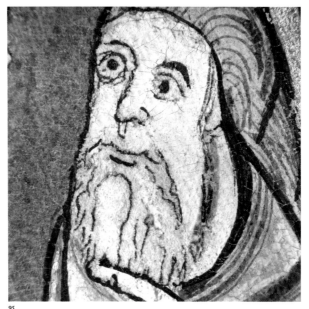

95

Another possible scenario is that the painting stage was done in a series
of passes. Unfinished manuscripts often reveal that each layer of painting was
applied as a pass through the entire quire or portion of a book, sometimes with
the gilding complete but no colors applied on some pages and with the gilding
and first layers of color, but no more, on others, as in the Winchester Bible.[53] This
working method may have been chosen to make effective use of a batch of pig-
ment when freshly made up or perhaps to speed the process and bring multiple
leaves to the same level of finish at once. In the St. Albans Psalter, quires 21 and 22
appear to exhibit effects of such passes, with the white highlighting of the drap-

eries in quire 22 (crosshatched but not fully filled in) less complete than in quire 21. Passes are best observed in the faces: in the elderly bearded men, the pass with blue pigment used in the initials for Psalms 42 and 43 (both in quire 10 and on facing pages) (figs. 93, 94) seems to have been overlooked in the initial for Psalm 36 (in quire 9) (fig. 95). And in a quire where the figures are clearly done by Artist 1, some faces were painted with scumbled whites with touches of color on bare parchment, as if emulating or being finished by Artist 2 (fig. 96). Perhaps this process of passes explains why some faces are left completely uncolored and others have varying degrees of modeling, while still others display a hybrid of multiple techniques.

Fig. 96
Psalm 103, Initial *B* (detail)
St. Albans Psalter, p. 276

The initial was painted by Artist 1, but the face was painted in the manner more typical of Artist 2.

Conclusion

The aim of this recent study has been to take advantage of an unprecedented opportunity for a close reexamination of the St. Albans Psalter and to use it to challenge assumptions and hypotheses that are divorced from the materiality of the object. A number of these hypotheses are in fact contradicted by the physical evidence, such as the matter of the dirt on the outer pages of the Alexis Quire and the circumstances of the insertion of the so-called Christina Initial. Puzzles remain, problems are unresolved, and many lines of inquiry await the efforts of future investigators. The psalter is exceptional in so many ways that firm conclusions about issues such as the date of its manufacture are hampered by a lack of comparative material. This essay has therefore highlighted physical features deserving of more detailed attention in the future, including the use of different kinds of gold and different methods of its application, a matter that has received surprisingly little attention in the past. Perhaps the proposal made here that deserves to have the most wide-ranging influence on future studies is the possibility that the miniatures and psalm initials may have been—more often than usually realized—collaborative enterprises. At the same time we hope to have reignited interest in matters that may have previously seemed settled. Much of the discussion of the psalter in recent decades has been concerned with debating backwards and forwards the centrality (or otherwise) of one (or both) of the two personalities who are external to the manuscript, namely Christina of Markyate and Abbot Geoffrey of St. Albans. However, it remains impossible to say for sure what influence, if any, either of them had on the book. We therefore propose that the time is now ripe for a close reassessment of the primary personality internal to the manuscript, whose influence on the appearance of the book is certain: the Alexis Master.

Notes

1. For a discussion of patronage, see the essay by Collins in this volume.

2. Jane Geddes, *The St Albans Psalter: A Book for Christina of Markyate* (London, 2005), pp. 84–85, adapted from her website at the University of Aberdeen, accessed December 12, 2012, http://www.abdn.ac.uk/stalbanspsalter/, in turn adapted from C. R. Dodwell's discussion of "the first artist" and "the second artist" in "Iconography and Style of the Initials," in Otto Pächt, C. R. Dodwell, and Francis Wormald, *The St. Albans Psalter (Albani Psalter)* (London, 1960), p. 199.

3. Otto Pächt, "The Pictorial Cycle," in Pächt, Dodwell, and Wormald, *St. Albans Psalter*, p. 49 and passim. The name is adapted from the German of Adolph Goldschmidt, *Der Albanipsalter in Hildesheim und seine Beziehung zur symbolischen Kirchensculptur des XII. Jahrhunderts* (Berlin, 1895).

4. Differences of style were noted by Peter Kidd, "Contents and Codicology," in *The St Albans Psalter (Albani Psalter)*, facsimile edition, commentary by Jochen Bepler, Peter Kidd, and Jane Geddes (Simbach am Inn, Germany, 2008), pp. 123–28.

5. E.g., Rodney M. Thomson, *Manuscripts from St Albans Abbey, 1066–1235* (Woodbridge, Suffolk, 1982), p. 26; Paul Binski and Stella Panayotova, eds., *The Cambridge Illuminations: Ten Centuries of Book Production in the Medieval West*, exh. cat. (Cambridge: Fitzwilliam Museum / London: Harvey Miller, 2005), no. 24.

6. Thomson, *Manuscripts from St Albans*, pp. 24–27.

7. London, British Library, Cotton Ms. Titus D.xvi; Kristine E. Haney, "The St Albans Psalter: A Reconsideration," *Journal of the Warburg and Courtauld Institutes* 58 (1995), pp. 1–28, especially pp. 8–10. Kidd, "Contents and Codicology," p. 128, suggests that the *Psychomachia* drawings may be by the Alexis Master himself.

8. See the essay by Collins in this volume.

9. L. Delisle, *Rouleaux des morts du IXe au XVe siècle, recueillis et publiés . . .* (Paris, 1886), pp. 281–344; L. Delisle, *Rouleau mortuaire du B. Vital, Abbé de Savigny, contenant 207 titres écrits en 1122–1123 dans différentes églises de France et d'Angleterre: Édition phototypique avec introduction* (Paris, 1909). The mortuary roll is digitized online, accessed December 12, 2012, http://www.culture.gouv.fr/Wave/image/archim/Pages/03752.htm.

10. Reproduced in Thomson, *Manuscripts from St Albans*, pl. 16, and in Delisle, *Rouleau mortuaire*, pl. XXI.

11. See the essay by Collins in this volume.

12. *Vie de Christina de Markyate*, edited and translated by Paulette L'Hermite-Leclercq and Anne-Marie Legras, Sources d'Histoire Médiévale, publiées par l'Institut de Recherche et d'Histoire des Textes 35 (Paris, 2007), vol. 2, pp. 27–33, 40.

13. Bernhard Gallistl, "Der St. Albans Psalter und seine liturgische Verwendung," *Concilium medii aevi* 15 (2012), pp. 213–54.

14. Kathryn B. Gerry, "The Alexis Quire and the Cult of Saints at St. Albans," *Historical Research* 82 (2009), pp. 593–612; Rodney M. Thomson, "The St Albans Psalter: Abbot Geoffrey's Book?," in *Der Albani-Psalter: Stand und Perspektiven der Forschung / The St Albans Psalter: Current Research and Perspectives*, edited by Jochen Bepler and Christian Heitzmann (Hildesheim, forthcoming).

15. *The Account-Book of Beaulieu Abbey*, edited by S. F. Hockey (London, 1975), pp. 195–98. This document is analyzed in Michael Gullick, "From Parchmenter to Scribe: Some Observations on the Manufacture and Preparation of Medieval Parchment Based on a Review of the Literary Evidence," in *Pergament: Geschichte, Struktur, Restaurierung, Herstellung*, edited by Peter Rück (Sigmaringen, Germany, 1991), pp. 145–57, appendixes A, B. We have converted all prices into pence for ease of comparison due to present-day lack of familiarity with the predecimal British currency, which until 1971 had 12 pence (d) to a shilling (s) and 20s to a pound (£), or 240d.

16. Haney, "St Albans Psalter," pp. 1nn2–4, 2nn5–6, 19; Morgan Powell, "Making the Psalter of Christina of Markyate (The St. Albans Psalter)," *Viator* 36 (2005), pp. 293–335, especially p. 301; Gerry, "Alexis Quire," p. 599.

17. New York, Morgan Library & Museum, Ms. M.736, extensively digitized and described online, accessed December 12, 2012, http://corsair.morganlibrary.org/; C. M. Kauffmann, *Romanesque Manuscripts, 1066–1190*, A Survey of Manuscripts Illuminated in the British Isles, vol. 3 (London, 1975), no. 34.

18. Gerry, "Alexis Quire," p. 599.

19. Verdun, Bibliothèque de la codecom de Verdun, Ms. 70, fully digitized and described online, accessed December 12, 2012, http://www1.arkhenum.fr/bm_verdun_ms/_app/index.php?tri=&saisie=70; Kauffmann, *Romanesque Manuscripts*, no. 31.

20. Kidd, "Contents and Codicology," pp. 100–102.

21. *Willelmi Malmesbiriensis, Monachi Gesta Pontificum Anglorum*, edited by N. E. S. A. Hamilton, Chronicles and Memorials, Rolls Series 52 (London, 1870), pp. 69–70, quoted in and translated by Sally Elizabeth Dormer, "Drawing in English Manuscripts, c. 950–c. 1385: Technique and Purpose" (PhD diss., Courtauld Institute of Art, University of London, 1991), p. 34.

22. The complementary techniques used for the study of the pigments were X-ray fluorescence (XRF) spectroscopy and Raman spectroscopy. Neither requires the removal of samples, makes physical contact with the object, or alters it in any way.

23. John Delaney, senior imaging scientist at the National Gallery of Art, Washington D.C., performed fiber optic reflectance spectrophotometry (FORS ASD Inc. FieldSpec 3, 350–2500 nm) and infrared reflectography and multispectral imaging (QImaging Retiga 4000R, 400–1000 nm) on a

limited number of leaves in November 2012, when he generously brought his instrumentation to the Getty Conservation Institute.

24. The reflectance spectra for both the purple colorants chrozophora tinctoria and lichen are very similar, preventing specific identification from the FORS data. See Doris Oltrögge, "Der Technik der Buchmalerei," in *Romanik*, Geschichte der Buchkultur 4, edited by Andreas Fingernagel (Graz, Austria, 2007), vol. 1, p. 312.

25. The blue mineral lazurite is S_3^-/S_2^- in a $Na_8[Al_6Si_6O_{24}]S_n$ matrix. See Catherine M. Schmidt, Marc S. Walton, and Karen Trentelman, "Characterization of Lapis Lazuli Pigments Using a Multitechnique Analytical Approach: Implications for Identification and Geological Provenancing," *Analytical Chemistry* 81 (2009), pp. 8513–18.

26. Helen Howard, *Pigments of English Medieval Wall Painting* (London, 2003), p. 29.

27. Azurite, a mineral blue mined in Europe and frequently used in manuscript illumination as an alternative to ultramarine, has not often been scientifically identified in Romanesque manuscripts. See Oltrögge, "Technik," p. 313.

28. For the ninth-century text, see R. P. Johnson, "The 'Compositiones Variae' from Codex 490, Biblioteca Capitolare, Lucca, Italy," *Illinois Studies in Language and Literature* 23, no. 3 (1939). For Theophilus, see *On Divers Arts*, translated with introduction and notes by John G. Hawthorne and Cyril Stanley Smith (Chicago, 1963; reprinted New York, 1979), pp. 29–31. The manufacture of gold leaf described in both texts is discussed in A. Caffaro, *Scrivere in oro: Ricettari medievali d'arte e artigianato (secoli IX–XI), Codici di Lucca e Ivrea* (Naples, 2003), pp. 16–21.

29. Theophilus, *On Divers Arts*, pp. 34–37.

30. Hereford Cathedral, Ms. O.I.8; Kauffmann, *Romanesque Manuscripts*, no. 33; R. A. B. Mynors and R. M. Thomson, with a contribution on the bindings by Michael Gullick, *Catalogue of the Manuscripts of Hereford Cathedral Library* (Cambridge, 1993), pp. 8, 9, color pls. 3a–d.

31. Theophilus, *On Divers Arts*, p. 31.

32. Ibid., p. 30.

33. Bury Bible, Cambridge, Corpus Christi College, Ms. 2; Kauffmann, *Romanesque Manuscripts*, no. 56; Binski and Panayotova, eds., *Cambridge Illuminations*, no. 19; Rodney M. Thomson, *The Bury Bible* (Rochester, N.Y., 2001). Dover Bible, Cambridge, Corpus Christi College, Ms. 4; Kauffmann, *Romanesque Manuscripts*, no. 69; Binski and Panayotova, eds., *Cambridge Illuminations*, no. 21.

34. This identification remains speculative until the presence of copper and zinc can be confirmed using X-ray fluorescence.

35. We employ here terminology established by Sally Dormer in the still-unpublished dissertation she kindly made available to us, "Drawing in English Manuscripts."

36. Leiden, Universiteitsbibliotheek, Ms. BPL 114 B; Thomson, *Manuscripts from St Albans*, pp. 113–14.

37. Cambridge, King's College, Ms. 19; Thomson, *Manuscripts from St Albans*, pp. 23–24, 84, no. 7; Binski and Panayotova, eds., *Cambridge Illuminations*, no. 24.

38. Cambridge, Pembroke College, Ms. 120; Kauffmann, *Romanesque Manuscripts*, no. 35; Binski and Panayotova, eds., *Cambridge Illuminations*, no. 20.

39. On reexamination, we found no evidence within the initials that they were originally executed in partial tinting, as suggested by Kidd, "Contents and Codicology," p. 132.

40. Pächt, Dodwell, and Wormald, *St Albans Psalter*, pp. 199–205; University of Aberdeen website, accessed December 12, 2012, http://www.abdn.ac.uk/stalbanspsalter/english/essays/artists.shtml#psalterstyle; Geddes, *St Albans Psalter*, pp. 81–86; Kidd, "Contents and Codicology," p. 135.

41. Geddes, *St Albans Psalter*, p. 85.

42. Respectively, Geddes on the University of Aberdeen website, accessed December 12, 2012, http://www.abdn.ac.uk/stalbanspsalter/english/essays/artists.shtml#psalterstyle; Dodwell, "Iconography and Style of the Initials," p. 199.

43. Winchester Cathedral, Ms. 17; Walter Oakeshott, *The Two Winchester Bibles* (Oxford, 1981), with an important review by T. A. Heslop, "Books for Use and Beauty," *Art History* 5, no. 1 (1982), pp. 124–28; Larry Ayres, "Collaborative Enterprise in Romanesque Manuscript Illumination and the Artists of the Winchester Bible," in *Medieval Art and Architecture at Winchester Cathedral*, British Archaeological Association Conference Transactions 6 (1983), pp. 20–35; Claire Donovan, *The Winchester Bible* (London, 1993), with an important review by T. A. Heslop in the *Burlington Magazine* 136, no. 1096 (July 1994), p. 467.

44. For details of artistic practices, see Jonathan J. G. Alexander, *Medieval Illuminators and Their Methods of Work* (New Haven, 1992); Christopher de Hamel, *Medieval Craftsmen: Scribes and Illuminators* (London, 1992), chapter 3.

45. Pächt, Dodwell, and Wormald, *St. Albans Psalter*, p. 199; Geddes, *St Albans Psalter*, p. 84; Kidd, "Contents and Codicology," p. 132.

46. Kidd, "Contents and Codicology," p. 133.

47. London, British Library, Additional Ms. 37472; London, Victoria and Albert Museum, Ms. 661; New York, Morgan Library & Museum, Ms. M.521, Ms. M.724; Kauffmann, *Romanesque Manuscripts*, no. 66; Binski and Panayotova, eds., *Cambridge Illuminations*, no. 25; *The Eadwine Psalter: Text, Image and Monastic Culture in Twelfth-Century Canterbury*, edited by Margaret Gibson, T. A. Heslop, and Richard W. Pfaff (London, 1992), passim and pls. 7–14.

48. Theophilus, *On Divers Arts*, pp. 17–18.

49. London, British Library, Royal Ms. 13 D.vi, Ms. 13 D.vii; Thomson, *Manuscripts from St Albans*, pp. 99–100, nos. 36, 37.

50. Ayres, "Collaborative Enterprise," p. 23.

51. *Chronicles of Matthew Paris: Monastic Life in the Thirteenth Century*, edited, translated, and with an introduction by Richard Vaughan (Gloucester, England, 1984; reprinted 1986), p. 25.

52. *Gesta Abbatum Monasterii Sancti Albani a Thoma Walsingham*, edited by Henry Thomas Riley (London, 1867), vol. 1, pp. 84–85.

53. E.g., Donovan, *Winchester Bible*, figs. 15, 23, 25, 62.

Appendix 1, Physical Description of the St. Albans Psalter

The St. Albans Psalter is composed of 209 leaves of parchment, probably made from calfskin, arranged in twenty-three quires, all but four of them composed of ten leaves (five bifolia) each; the leaves are paginated from 1 to 417 in the upper right corner of rectos. A leaf of the psalms is missing between pages 266 and 267; a leaf that belongs after page 414 is now in the Schnütgen Museum, Cologne; and the final few leaves, probably blank, have been excised. The leaves were cropped during successive rebindings, occasionally affecting the text and decoration, and are now approximately 2.75 × 18.50 cm (10⅞ × 7¼ in.) in size. Prickings in the outer margins, used to guide the ruling, occasionally survive. The ruling of most of the volume is so faint as to be almost invisible, but some quires near the end were deeply scored with a sharp point. The psalms and following texts are ruled for a single column of twenty-two lines of text per page, except the deeply scored quires, which are ruled for two columns of twenty-five lines each. The texts are written by several scribes, some of whose handwriting can be recognized in other manuscripts from St. Albans.

At the time of writing (2013), the volume is disbound. It would originally have had an English twelfth-century binding using oak boards. It was rebound in pigskin probably in Germany in the seventeenth century and was repaired in 1939.

The following diagrams show the arrangement of the first five quires and their images. Numerals refer to page numbers.

1 Blank; added inscriptions
2 Computistical memoranda

3 January
4 February

5 March
6 April

7 May
8 June

9 July
10 August

11 September
12 October

13 November
14 December

15 Computistical tables
16 Blank

17 Fall
18 Expulsion

19 Annunciation
20 Visitation

21 Nativity
22 Shepherds

23 Magi before Herod
24 Journey of the Magi

25 Adoration of the Magi
26 Dream of the Magi

27 Return of the Magi
28 Presentation in the Temple

29 Flight into Egypt
30 Massacre of the Innocents

31 Return from Egypt
32 Baptism of Christ

33 First Temptation of Christ
34 Second Temptation of Christ

35 Third Temptation of Christ
36 Meal in the House of Simon

37 Entry into Jerusalem
38 Washing of the Feet

39 Agony in the Garden
40 Christ Waking the Disciples

41 Last Supper
42 Betrayal and Arrest of Christ

43 Mocking
44 Flagellation

45 Pilate Washing His Hands
46 Carrying the Cross

47 Descent from the Cross
48 Entombment

49 Harrowing of Hell
50 Women at the Tomb

51 Magdalene Announcing the Resurrection
52 Doubting Thomas

53 Saint Martin
54 Ascension

55 Pentecost
56 David Harping

57 Alexis Miniature; Chanson prologue
58 Beginning of Chanson

59 Chanson
60 Chanson

61 Chanson
62 Chanson

63 Chanson
64 Chanson

65 Chanson
66 Chanson

67 Chanson
68 End of Chanson; Saint Gregory paraphrases

69 The Road to Emmaus
70 Supper at Emmaus

71 Christ's Disappearance from Emmaus; marginal text
72 Battling Knights; Beatus Initial; marginal text

abbot. The (male) head of an abbey, a type of monastery.

anchoress. A female anchorite; a woman who, for religious reasons, lives separate from **lay** society; similar to a hermit or recluse.

Beatus Initial. The elaborate initial *B* of "Beatus vir" (Blessed is the man), the first words of Psalm 1.

Benedictine. A monk or nun following the rule, or lifestyle, laid down by Saint Benedict.

bifolium (pl. bifolia). A sheet of paper or **parchment** folded down the middle to form two leaves.

calendar. The months of the year, usually laid out one month per page, with relevant information such as the dates of saints' feast days and an indication of their relative importance; sometimes also used for recording **obits**.

canticle. Hymn of praise, extracted from the Bible.

chanson. French for "song"; the French *Chanson de Saint Alexis* in the St. Albans Psalter is referred to in its own prologue as a *chançun*.

codex. A handwritten book composed of sewn, folded sheets of parchment or paper.

collect. A type of prayer, typically found in **psalters** after the **litany**.

creed. A type of prayer formally expressing particular religious beliefs.

cycle. See **prefatory cycle**.

diptych. Two images facing each other, usually on separate panels hinged together at the middle.

exemplar. The text or image from which another one is copied.

gutter. The fold in a **bifolium**, or where separate **bifolia** adjoin.

historiated initial. An initial letter of a text containing an image of a person or scene.

illumination. Embellishment using colors, and often gold.

incipit. Latin for "it begins"; the opening words of a text often used to identify a text. For example, "Our Father" is the incipit of the Lord's Prayer.

invention of relics. The occasion on which the relics of a saint are discovered; this event may be recorded in a **calendar** for subsequent commemoration.

lay. An adjective identifying an individual as not institutionally religious (hence layman, laywoman).

leaf. One half of a **bifolium**; in a printed book, a single leaf usually has two **page** numbers (e.g., 23 on the front, or recto, and 24 on the back, or verso).

litany. A series of pleas addressed to saints, individually and in groups (e.g., "Saint Benedict, pray for me," or "All martyrs, pray for me"), followed by short prayers and **petitions**; typically found in **psalters** after the **canticles**.

miniature. A freestanding picture, not necessarily small in size; from the Latin word *minium*, a pigment that was used to decorate early manuscripts.

oak galls. Growths found on oak trees that are high in tannic and gallic acids.

obit. A record of a person's death, typically written in a **calendar** as a reminder so that the person could be remembered each year on the anniversary of his or her death.

Occam's razor. The principle that between competing hypotheses, the one that makes the fewest assumptions is to be preferred.

opening. The view of an open manuscript with two facing pages visible.

page. The front (recto) or back (verso) of a **leaf**.

parchment. The forerunner of paper as a material for writing on, made from specially treated animal skin; also known as membrane or vellum.

pentimenti. Differences between the final painting and the preparatory drawing underneath that indicate a change of design. The plural of *pentimento*, the word comes from the Italian word *pentire*, meaning "to repent" or "to change one's mind."

petition. A prayer to God in the form of appeals, in three series, *from* things (e.g., danger), *through* things (e.g., the Resurrection), and *for* things (e.g., good health).

plummet. A lead-point drawing implement that leaves a gray mark on the page; from the Latin word *plumbum*, meaning "lead." In medieval manuscripts, a plummet was used for underdrawings and ruling lines for text. It preceded the use of graphite (carbon) for pencils.

prefatory cycle. A series of **miniatures** preceding the main text.

prior. The male head of a priory, a religious institution subordinate to an abbey and its **abbot**. In English cathedral priories such as Rochester or Canterbury, the prior is below a bishop or archbishop in the hierarchy.

prioress. The female equivalent of a **prior**.

psalter. A volume usually containing a **calendar**, the psalms, **canticles** and **creeds**, a **litany**, and **collects**, and sometimes other material such as a **prefatory cycle** or other texts.

quire. An individual section of a **codex** consisting of one or more **bifolia** nested one inside another (like a modern newspaper).

recto. See **page**.

rubric. An instruction or heading in a book, typically written in red ink; rubrication is the process of supplying rubrics.

scriptorium. A room specifically for writing, doubtless offering good light and shelter from the elements; also often used to describe the group of scribes and illuminators working at a given institution.

vellum. See **parchment**.

verso. See **page**.

vita. Latin for "life"; a written *vita* is therefore a biography in Latin.

Suggestions for Further Reading

The foundational studies of the St. Albans Psalter are Adolph Goldschmidt, *Der Albanipsalter in Hildesheim und seine Beziehung zur symbolischen Kirchensculptur des XII. Jahrhunderts* (Berlin, 1895), now available online and as a print-on-demand reprint; and Otto Pächt, C. R. Dodwell, and Francis Wormald, *The St. Albans Psalter (Albani Psalter)* (London, 1960), not usually available outside research libraries.

The first modern study to reassess the materiality of the volume is Kristine Edmondson Haney, "The St Albans Psalter: A Reconsideration," *Journal of the Warburg and Courtauld Institutes* 58 (1995), pp. 1–28. The only study to reproduce all the miniatures and many of the initials in color is Jane Geddes, *The St Albans Psalter: A Book for Christina of Markyate* (London, 2005), largely based on her website at the University of Aberdeen, http://www .abdn.ac.uk/stalbanspsalter/, which has images of the entire manuscript except its binding and flyleaves, with commentaries, translations, and an extensive bibliography of works up to 2006. The most recent monograph is Jochen Bepler, Peter Kidd, and Jane Geddes, *The St Albans Psalter (Albani Psalter)* (Simbach am Inn, Germany, 2008), written to accompany a facsimile.

Most other studies focus on particular aspects of the manuscript, such as the Alexis Quire or the psalm initials, notably Kristine Haney, *The St. Albans Psalter: An Anglo-Norman Song of Faith* (New York, 2002); Morgan Powell, "Making the Psalter of Christina of Markyate (The St. Albans Psalter)," *Viator* 36 (2005), pp. 293–335; Kathryn B. Gerry, "The Alexis Quire and the Cult of Saints at St. Albans," *Historical Research* 82 (2009), pp. 593–612; and Patricia Stirnemann, "The St Albans Psalter: One Man's Spiritual Journey," in *Der Albani-Psalter: Stand und Perspektiven der Forschung / The St Albans Psalter: Current Research and Perspectives*, edited by Jochen Bepler and Christian Heitzmann (Hildesheim, forthcoming). For two recent contrasting assessments of the date of the psalter, see Rodney M. Thomson, "The St Albans Psalter: Abbot Geoffrey's Book?" in *Der Albani-Psalter*, ed. Bepler and Heitzmann, forthcoming; and Donald Matthew, "The Incongruities of the St Albans Psalter," *Journal of Medieval History* 34 (2008), pp. 396–416.

For introductions in French, English, and German to medieval Latin manuscript psalters, see the introductions in Victor Leroquais, *Les Psautiers manuscrits latins des bibliothèques publiques de France*, vol. 1 (Mâcon, France, 1940); Haney, *St. Albans Psalter*; and *The Illuminated Psalter: Studies in the Content, Purpose and Placement of Its Images*, edited by F. O. Büttner (Turnhout, Belgium, 2004). For a detailed technical description of the St. Albans Psalter, see Renate Giermann, Helmar Härtel, and Marina Arnold, *Handschriften der Dombibliothek zu Hildesheim*, vol. 2, *Hs 700–1050; St. God. Nr. 1–51; Ps 1–6; J 23–95*, Mittelalterliche Handschriften in Niedersachsen 9 (Wiesbaden, 1993).

Several translations of the Latin *vita* of Christina of Markyate are available. That with the most important introduction in English is *The Life of Christina of Markyate: A Twelfth Century Recluse*, edited and translated by C. H. Talbot (Oxford, 1959, revised and reprinted 1987, 1997, 1998), but for an improved Latin edition, with a translation into French and an extensive commentary that supersedes Talbot, see *Vie de Christina de Markyate*, edited and translated by Paulette L'Hermite-Leclercq and Anne-Marie Legras, Sources d'Histoire Médiévale, publiées par l'Institut de Recherche et d'Histoire des Textes 35 (Paris, 2007). For studies of the *vita*, see Rachel M. Koopmans, "The Conclusion of Christina of Markyate's *Vita*," *Journal of Ecclesiastical History* 51 (2000), pp. 663–98; the essays in *Christina of Markyate: A Twelfth-Century Holy Woman*, edited by Samuel Fanous and Henrietta Leyser (London, 2005); and Nancy Partner, "Christina of Markyate and Theodora of Huntingdon: Narrative Careers," in *Reading Medieval Culture: Essays in Honor of Robert W. Hanning*, edited by Robert M. Stein and Sandra Pierson Prior (Notre Dame, Ind., 2005), pp. 111–31.

Acknowledgments

Collaboration is one of the most rewarding aspects of museum work, and I am grateful for the many conversations held with co-authors Peter Kidd and Nancy Turner in the presence of the St. Albans Psalter and related manuscripts during the summer and fall of 2012. We are all pleased to be able to share this magnificent work of art through this book and the related exhibition *Canterbury and St. Albans: Treasures from Church and Cloister*. Neither the book nor exhibition would have been possible without Jochen Bepler, librarian of Dombibliothek Hildesheim, whose desire to make this treasure accessible to the public enabled the psalter's close study in the Getty conservation laboratories, the exhibition, and this publication. I also thank Gerhard Lutz, curator at the Dom-Museum, Hildesheim, for his collegiality and insight, and Bernhard Gallistl of the Dombibliothek Hildesheim for his assistance both in Hildesheim and Los Angeles.

On behalf of all the authors, I would like to acknowledge the trust and generosity of the librarians and conservators who enabled our close study of manuscripts for this project: Kathleen Doyle and Gayle Whitby at the British Library; Claire Ben Lakhdar-Kreuwen at the Bibliothèque de la codecom de Verdun; Christopher de Hamel, Gill Cannell, and Suzanne Paul at Corpus Christi College, Cambridge; Stella Panayotova and Kristine Rose at the Fitzwilliam Museum, Cambridge; Rosemarie Firman at Hereford Cathedral Library; Peter Jones at King's College, Cambridge; and William Voelkle, Maria Fredericks, and Frank Trujillo at the Morgan Library & Museum, New York. I would also like to thank John Delaney from the National Gallery of Art, Washington, who conducted FORS analysis of the St. Albans Psalter with Getty staff and then generously lent his camera so that the Getty team could extend its imaging study of the manuscript.

I am grateful as well for the collegiality and support of all those at the J. Paul Getty Museum who dedicated their time and expertise to this project. I offer special thanks to Jeffrey Weaver, associate curator of sculpture and decorative arts, who was co-curator of the exhibition. Thomas Kren, associate director for collections, was instrumental in the planning stages of the exhibition. The project benefited over time from the leadership of directors Michael Brand, David Bomford, James Cuno, and Timothy Potts.

Elizabeth Morrison, senior curator of manuscripts, and Antonia Boström, senior curator of sculpture and decorative arts, were generous with their time and encouragement throughout the project. Quincy Houghton, associate director for exhibitions, Susan McGinty, senior exhibitions coordinator, and John Giurini, assistant director for public affairs, were instrumental to the success of the exhibition. Getty conservators Jane Bassett, Brian Considine, and Nancy Turner, with mount makers Stephen Heer, Mark Mitton, and Adrienne Pamp, oversaw the safe handling of the exhibition's objects, while designers Robert Checchi and Donna Pungprechawat conceptualized the stunning display. The installation depended on the professionalism of preparators Rita Gomez, Kevin Marshall, Michael Mitchell, and their department. Educators Toby Tannenbaum and Tuyet Bach contributed their expertise in public education and audience experience to the project, and editor Chris Keledjian helped lend clarity to the gallery didactics. In the Registrars' office, Sally Hibbard, Cherie Chen, Leigh Grissom, and Kanoko Sasao arranged the transit, installation, and publication of the objects. Michael Smith, Johanna Herrera, and Rebecca Truszkowski in Collections Information and Access assured the quality of photography for this publication. I am grateful to colleagues Richard Leson, Jeffrey Hamburger, and Allie Terry-Fritsch who generously read drafts of my essay, offering valuable suggestions for improvement. I would also like to extend warm thanks to Manuscripts Department staff members Erene Morcos and Melanie Sympson for research assistance and Katy Corella, Jennifer Tucker, Morrigan Dawn, and Andrea Hawken for administrative and technical assistance

Finally, I would like to acknowledge the Getty Publications staff: editor Elizabeth Nicholson for her sound guidance; production coordinator Elizabeth Kahn, who together with designer Kurt Hauser transformed the authors' texts into an exceptionally beautiful book; editorial consultant Ann Grogg for her careful editing of the manuscript; and photo researcher Pam Moffat; assistant editor Ruth Lane; and proofreader Karen Stough. I would also like to thank publisher Kara Kirk and editor in chief Rob Flynn for their support of this book.

Kristen Collins

Index

This publication is issued in conjunction with the exhibition *Canterbury and St. Albans: Treasures from Church and Cloister*, on view at the J. Paul Getty Museum at the Getty Center, Los Angeles, from September 20, 2013, to February 2, 2014.

Published by the J. Paul Getty Museum, Los Angeles
Getty Publications
1200 Getty Center Drive, Suite 500
Los Angeles, California 90049-1682
www.getty.edu/publications

Elizabeth S. G. Nicholson, *Editor*
Kurt Hauser, *Designer*
Elizabeth Chapin Kahn, *Production Coordinator*

Printed in Hong Kong

Library of Congress Cataloging-in-Publication Data
The St. Albans psalter : painting and prayer in medieval England / Kristen Collins, Peter Kidd, and Nancy Turner.
 pages cm
 Includes index.
 "The St. Albans Psalter: Painting and Prayer in Medieval England is published on the occasion of the exhibition Canterbury and St. Albans: Treasures from Church and Cloister on view at the J. Paul Getty Museum at the Getty Center, Los Angeles, from September 20, 2013, to February 2, 2014."—ECIP galley.
 ISBN 978-1-60606-145-9 (pbk.)
 1. St. Albans psalter. 2. Psalters—England—St. Albans—History. 3. Illumination of books and manuscripts, Medieval—England—St. Albans. I. Collins, Kristen M. author. II. Kidd, Peter, 1964- author. III. Turner, Nancy, 1960- author. IV. Collins, Kristen M. author. St. Albans psalter. V. J. Paul Getty Museum. VI. Title: Canterbury and St. Albans, treasures from church and cloister.
 ND3357.S12S7 2013
 745.6'70942—dc23

 2013006536

FRONT COVER: Initial *A*, St. Albans Psalter, p. 166. Dombibliothek Hildesheim HS St. God. 1 (Property of the Basilica of St. Godehard, Hildesheim)
FRONT FLAP: *The Agony in the Garden*, St. Albans Psalter, p. 39 (detail, fig. 18)
BACK COVER: *The Expulsion from Paradise*, St. Albans Psalter, p. 18 (detail, fig. 16)
PAGE 1: Calendar Page for January, St. Albans Psalter, p. 3 (detail, fig. 11)
PAGE 2: St. Albans Psalter, p. 24 (detail)
PAGES 4–5: *Scenes from the Life of Saint Alexis*, St. Albans Psalter, p. 57 (detail, fig. 26)

Illustration Credits

Every effort has been made to contact the owners and photographers of objects reproduced here whose names do not appear in the captions or in the illustration credits listed below. Anyone having further information concerning copyright holders is asked to contact Getty Publications so this information can be included in future printings.

Figs. 1, 2, 7, 9–19, 21–24, 26–46, 48, 51, 66, 67, 69, 92, 93: St. Albans Psalter, Dombibliothek Hildesheim HS St. God. 1 (Property of the Basilica of St. Godehard, Hildesheim)
Fig. 3: David Fuller, Cartographer
Fig. 4: The Granger Collection, New York
Fig. 5: © Monheim/Opitz
Fig. 6: © The British Library Board, Cotton Titus D.xvi, fol. 6
Fig. 8: © The British Library Board, Cotton Tiberius C.vi, fol. 14
Fig. 25: Stadtbibliothek Trier, Ms 1378/103 f 132v (Repro: Anja Runkel)
Figs. 49, 61, 79, 86: The Morgan Library & Museum, New York
Fig. 50: Paris, Archives nationales
Figs. 47, 53–55, 57–60, 68–78, 80–84, 87–97: Peter Kidd / Nancy Turner
Figs. 56, 63: Mappa Mundi Trust and Dean and Chapter of Hereford Cathedral
Fig. 64: Leiden University Library, ms. BPL 114 B, fol. 147v
Fig. 65: By permission of the Provost and Scholars of King's College, Cambridge